BETWEEN TOMORROW AND YESTERDAY

Tripping into nowhere behind nothing

Felton Perry

Between Tomorrow And Yesterday by Felton Perry

ISBN 978-1-952027-47-5 (Paperback)
ISBN 978-1-952027-48-2 (Hardback)
ISBN 978-1-952027-49-9 (eBook)

This book is written to provide information and motivation to readers. Its purpose is not to render any type of psychological, legal, or professional advice of any kind. The content is the sole opinion and expression of the author, and not necessarily that of the publisher.

Copyright © 2020 by Felton Perry

All rights reserved. No part of this book may be reproduced, transmitted, or distributed in any form by any means, including, but not limited to, recording, photocopying, or taking screenshots of parts of the book, without prior written permission from the author or the publisher. Brief quotations for noncommercial purposes, such as book reviews, permitted by Fair Use of the U.S. Copyright Law, are allowed without written permissions, as long as such quotations do not cause damage to the book's commercial value. For permissions, write to the publisher, whose address is stated below.

Printed in the United States of America.

New Leaf Media, LLC
175 S. 3rd Street, Suite 200
Columbus, OH 43215
www.thenewleafmedia.com

Two Plays by Actor/Writer Felton Perry

Sleep No More
A musical comedy based on "The Scottish Play" by William Shakespeare
Book and Lyrics by Felton Perry, Music composed by Gary Brooks

buy the bi and bye
A satire of the "black theatrical expression" that takes place in a small theatre

SLEEP NO MORE
FELTON PERRY

CONTENTS

MUSIC..xiii
CHARACTERS... xv
SYNOPSIS... xvii
PROLOGUE.. xxiii

ACT ONE

ACT ONE, SCENE ONE: BANQUET HALL............................1
ACT ONE, SCENE TWO: CORRIDOR..............................11
ACT ONE, SCENE THREE: DUNCAN'S CHAMBER...........16
ACT ONE, SCENE FOUR: BANQUET HALL20
ACT ONE, SCENE FIVE: DUNCAN'S CHAMBER................27
ACT ONE, SCENE SIX: BANQUET HALL30
ACT ONE, SCENE SEVEN: CORRIDOR OUTSIDE
 DUNCAN'S CHAMBER..34
ACT ONE, SCENE EIGHT: BANQUET HALL......................39
ACT ONE, SCENE NINE: CORRIDOR41
ACT ONE, SCENE TEN: BANQUET HALL44

ACT TWO

ACT TWO, SCENE ONE: CORRIDOR.................................49
ACT TWO, SCENE TWO: THE BANQUET HALL................59

ACT TWO, SCENE THREE: DUNCAN'S CHAMBER............61
ACT TWO, SCENE FOUR: BANQUET HALL........................64
ACT TWO, SCENE FIVE: CORRIDOR..................................67
ACT TWO, SCENE SIX: BANQUET HALL............................70

EPILOGUE: BANQUET HALL..83
buy the bi and bye...89

SETTING

There are three distinct playing areas:
 The banquet hall
 Duncan's chamber
 The corridor outside Duncan's chamber

MUSIC

ACT ONE

SONG	RATE	SINGER
1. Hey, Everybody	Up-tempo	MagicMindMonster/ Cast
2. Pretty Maiden	Up-tempo	Young Chamberlain / Cast
3. Escalate	Up-tempo	Cast
4. You Are the Song I Sing	Slow	Old Chamberlain
5. When Will I Get Used to War	Moderate	Lennox
6. Multicolored Panties	Moderate	Duncan/Cast
7. Kill for Me	Moderate	Macbeth, Lady Macbeth
8. The World Will Be Ours	Moderate	Macbeth, Lady Macbeth
9. Handsome Young Man	Slow	Kitchen Maid
10. Discoveries	Moderate	Young Chamberlain
11. Color of My Dreams	Slow	Kitchen Maid, Young Chamberlain

ACT TWO

12. Lie to (Bullshit) Me, Baby	Moderate	Baby Macbeth
13. Oh, So Deeply	Slow	Macbeth
14. Life Is a Joke	Moderate	Macduff
15. Banquo's Eulogy	Slow	Banquo
16. Hail, Macbeth	Slow	Cast
17. The World Is Ours	Up-tempo	Cast

CHARACTERS

OLD CHAMBERLAIN (Cecil)—a faithful and loyal servant who has resigned himself to a life of heartache ever since he lost his wife, Dolores.

YOUNG CHAMBERLAIN (Junebug)—an unhappy young man who dreams of being a singer. Raised alone by his father, Cecil, he wonders who his mother is.

PORTER (Dewey)—a crotchety old imp who plays the "fool." He and Cecil are bitter enemies because of Dolores.

KITCHEN MAID (Sookie)—a vivacious, earthy, beautiful young woman who is looking for a man.

LORD MACBETH—a moral warrior who allows his ambition to overwhelm him.

LADY MACBETH—a lonely woman who encourages her husband to go for what his ambition craves.

DUNCAN—the king who uses his position to do whatever he wants.

BANQUO—Macbeth's "killing buddy" who drinks a little more than a lot.

MACDUFF—Duncan's boyhood friend and school chum.

LENNOX—a poet who, because of his noble ranking, has war thrust upon him.

HUNCHBACK—an ageless woman who takes love wherever and whenever she can.

PREGNANT SERVANT GIRL

MENTIEFF—a soldier.

HOUSE SERVANTS
LADIES OF THE COURT

MAGICMINDMONSTER—the catalyst for Macbeth's ambition, and general mischief maker. This character consists of three persons: HECATE and her TWO STUDENT APPRENTICES. This character should be used—in addition to these places indicated in the script—wherever the director feels its involvement will enhance the action.

SYNOPSIS

Sleep No More is a musical comedy inspired by the Shakespearean classic *Macbeth*.

In *Macbeth*. a brave and morally sensitive man, Macbeth, murders in order to become king. He plots the dastardly deed with his wife, Lady Macbeth, and slays his king, kinsman, benefactor, and guest while he sleeps. In order to accomplish the deed, Lady Macbeth drugs the king's two chamberlains and lays out their daggers for her husband. Macbeth assassinates His Majesty with the weapons and then accuses and executes the unsuspecting attendants for the heinous crime of regicide.

In *Sleep No More*, the focus is on the chamberlains, a father-and-son team. They are the central characters. The Shakespearean tragedy serves as a springboard from which to discover who they are.

The play begins with the MagicMindMonster (the witches) setting the scene. The place is Macbeth's castle; the time is the evening after the victory of Scotland's loyal forces over the rebels—an occasion that calls for a celebration. The action unfolds. The Old Chamberlain (Cecil) is happy to be in Macbeth's castle where many years ago he met Dolores, his only true love and the Young Chamberlain's mother. The Young Chamberlain (Junebug) doesn't remember his mother. He was told that she died a few months after he was born. He is an unhappy lad who would rather be a singer than a king's loyal servant, much to his father's dismay. Their relationship is combative.

The Old Chamberlain also has a bitter relationship with the Porter (Dewey) because of Dolores. The Porter claims that Dolores was his "girl" until Cecil came along and stole her from him.

The Kitchen Maid (Sookie) falls head over heels in love with Junebug and asks the Porter to arrange for her to meet him. The Porter begrudgingly consents to do so.

In the meantime, Lady Macbeth has convinced her husband that murder is the only way for him to ever make his dream of becoming king come true. She approaches the chamberlains under the guise of celebrating Scotland's victory and seduces them into drinking from the narcotic cups. They pass out. Lady Macbeth takes their daggers and lays them out. Then she returns to the banquet hall, where Macbeth waits, and she tells him all is ready. Macbeth goes to do his part.

Unbeknownst to both of them, the Porter has overheard their every word. His curiosity is aroused, so he hides himself and observes.

Macbeth kills the king and is saluted by the MagicMindMonster with the famous Shakespearean passage:

Sleep no more.
Macbeth does murder sleep.

Macbeth is horrified. He rushes back to the banquet hall with the bloody daggers. Lady Macbeth scolds him for being a coward. She takes the daggers from him and returns to the king's chamber. The Porter follows, and from a hidden position, he watches with indescribable fear as Lady Macbeth dips her hands in the dead king's blood, smears the drugged chamberlains with it, and places the bloody daggers near them.

Lady Macbeth returns to Macbeth in the banquet hall. He declares his love for her, but a knocking at the gate breaks the mood, and they leave.

The Porter enters with the Kitchen Maid. He tells her to wait for him in his quarters. She goes, and the Porter answers the knocking, admitting Macduff and Lennox, who have come to awaken the king for the trip to his castle.

The Old Chamberlain wakes up. He discovers his dagger bloody and mistakenly thinks that he has killed his son. He cries and tells his dead son the truth about his mother, Dolores. He moans and asks God to forgive him. The Young Chamberlain wakes up.

The Old Chamberlain gets angry with him because he thinks the boy was playing with him, but at the same time, he is happy that the kid is alive. He concludes that the blood and the bloody daggers are part of one of the king's practical jokes and convinces his son to go along with it.

Macbeth meets Macduff and Lennox in the banquet hall and escorts them to the king's chamber.

Macduff goes in to wake up his good buddy but discovers that his king is dead. He runs from the chamber, screaming.

The Old Chamberlain goes and sees for himself that his lord is lifeless. Oh, oh.

The Porter and the Kitchen Maid enter into the chamber through a secret passageway. They tell the chamberlains of the plot to frame them for the murder and urge them to run. The Old Chamberlain decides to stay but wants to save his son. The Porter reluctantly consents to take the boy's place, but only after the MagicMindMonster intercedes.

The Porter and the Young Chamberlain exchange clothes, and the young people are sent away, leaving the two bitter love rivals—the Porter and the Old Chamberlain—to suffer whatever may come. They hear footsteps and pretend to sleep. Macbeth and Lennox enter. Macbeth cleverly leads Lennox along the trail of incriminating

evidence against the "sleeping" attendants until Lennox can only declare that they are guilty and must die. Macbeth agrees and executes them for his crime.

The king's funeral is a solemn, high ceremony punctuated by the wailing hypocrisy of Lord and Lady Macbeth.

Soon after, they are crowned king and queen of Scotland. They made it, but they are paying the price. Sitting alone on their thrones, the conniving couple's faces and behavior show the wear and tear of the deceitful treachery they have committed, and to top it all off, the MagicMindMonster invites the ghosts of the king, the Old Chamberlain, and the Porter to pay homage to the new royal family who shall *sleep no more.*

This play is inspired by the assassination of Duncan, king of Scotland, which Macbeth and his lady plan and execute in act 1 and act 2 of *Macbeth* by William Shakespeare.

PROLOGUE

Special MagicMindMonster.

MMM. <u>Fair is foul and foul is fair</u>: <u>Hover through the fog and filthy air</u> (*sings*).[1]

> Hey, everybody! You can have your dream.
> The MagicMindMonster is on the scene.
> What do you long for?
> Do you want to be true?
> The MagicMindMonster will do it for you.
> You'll have your dream.
> You'll be the very best.
> We'll take your sleep
> You won't have time to rest. Sleep no more.
> Stir, stir, stir.

(*To audience*) Hi. We are the MagicMindMonster—dream and special effectsperts. We like to help people reach their goals and have fun at the same time. We say if you got a dream, hold on to it. <u>Fair is foul and foul is fair: Hover through the fog and filthy air.</u> (*Speaks*)

[1] Underlined dialogue denotes direct quote from Shakespeare.

Let's meet tonight's dreamers. Here we are in the castle of Lord and Lady Macbeth in Inverness, Scotland. A warm and sunny country full of beautiful and happy people, especially since the government squashed the latest peasant rebellion. Yesterday, we were there. Saw it all. Lord Macbeth was awesome. Took no prisoners. After it was all over, we had a little fun with him and his ace boon, Banquo. Surprised them at the heath. Put something on their minds. Heh, heh. Macbeth wants to be king, but he doesn't want it bad enough. He doesn't have that burning sensation in the pit of his gut for power. The throne doesn't make him froth at the mouth like Lady Macbeth. She loves him and wants to be queen. And she wants it bad enough to do whatever it takes.

MMM gestures. A light comes up on Lady Macbeth.

LM. <u>Come, you spirits that tend on mortal thoughts! Unsex me here</u> . . . <u>Come to my woman's breasts, and take my milk for gall</u> . . .

She freezes.

MMM. Now, she ain't jivin'. She be for real. Chafing at the chastity belt. Heh, heh.
MCB (*from offstage*). Baby, I'm back!

Macbeth enters.

LM. <u>All hail Macbeth that shall be king hereafter.</u> MCB (*aside*). I've heard that somewhere before.
LM. <u>Hie thee hither that I may pour my spirits in thine ear.</u>
MCB. No time for that right now. Get everything ready to party.

LM. Why?

MCB. Duncan comes here tonight. LM. The king?

MCB. Yeah. The yoyo. My cousin. Mr. Life of the Party. LM. And when goes hence?

MCB. Tomorrow, as he purposes.

LM. Oh! Never shall sun that morrow see. MCB. What do you mean by that?

LM. He that's coming must be provided for. Leave the rest to me.

LM exits. MCB follows.

MMM. (*To audience*) She means the king must die. It shouldn't be too difficult to arrange. Fair is foul and foul is fair.

The MMM gestures.
Lights up on King Duncan and his chamberlains, Cecil and Junebug.

MMM. See the king and his servants have arrived in time. Very important ingredients for this most noble crime.

DUN. This castle hath a pleasant seat; the air nimbly and sweetly recommends itself unto our gentle senses.

MMM gestures. He freezes.

MMM. Duncan has no dreams. After all, he is king. He can have whatever and whoever he wants whenever, wherever, and however he wants. What I'm trying to say is, he is the *baddest malefactor* in the land. He also has a kinky sense of humor.

MMM gestures. Duncan unfreezes. Plays a cruel prank on the chamberlains. Freezes.

MMM. His servants, however, have dreams. Maybe we'll find out about them later.

MMM gestures.
Lights up on Banquo.

MMM. This is Banquo. Macbeth's killing buddy. A fierce warrior who is a deadly enemy to any who challenges the status quo, and a friend to all Scotch: Pinch, Chivas Regal, Johnnie Walker any label, Dewar's—you name it, and he loves it.

MMM gestures.
Banquo unfreezes.

BAN. <u>The air is delicate.</u> <u>Heaven's breath smells wooingly here.</u>

MMM gestures. He freezes.
Lights up on Macduff and Lennox.

MMM. This is Macduff. Boyhood school chum and closest friend to Duncan. When it comes to fighting for his king, he will kill a brick, but other than that, he's really a nice guy. A married man with a beautiful wife and a lovely child. He's the strong, silent type. He doesn't dream. Too childish.

MMM gestures. Macduff unfreezes.

MCD. I ain't got nothin' to say.

> *He freezes.*

MMM. And this is Lennox. The peasant rebellion was his first time in battle. His baptism in blood didn't go too well. He kept getting sick. He is no warrior. He would rather write poetry and chase butterflies. His naïveté might prove useful. Heh, heh.

> *MMM gestures. Lennox unfreezes.*

LEN. Lovely bird, high in the air.
Nestle in my true love's hair.

> Let her know I'll soon be there.
> As soon as I find my underwear.

> *MMM gestures. He freezes.*
> *Lights up on soldiers, servants, and ladies.*

MMM. And here are the rest of them. The Kitchen Maid, the Porter, the Hunchback, and others. Some have dreams, others don't. Some dream and tell, others won't. So let's get on with it.

> *MMM gestures.*
> *All lights go out.*

END OF THE PROLOGUE

ACT ONE

ACT ONE, SCENE ONE

BANQUET HALL

The Kitchen Maid and other servants are preparing the place for the victory party: banners with slogans, tables heaped with food, kegs of drink, etc. The Porter follows the Kitchen Maid everywhere she goes. He is trying to seduce her.

> *Knocking from offstage.*

POR. Knock, knock, knock. Check the number. Could be the wrong door.

> *Knocking continues*

POR. Knock your knees, why don't you? And give the gate a break.

> *He exits toward the knocking.*
> *A few moments pass, then he backs into the hall, facing a band of players (the MagicMindMonster in disguise).*

POR. What do you want? You can't just come crashing in here.
MMM. We're here to entertain for King Duncan's victory party. To celebrate his conquering the rebels.

POR. Those damned fool peasants. They got what they deserved. Imagine, rebelling because they weren't satisfied with the way things were. Hah. We showed them a thing or two. Now they're either satisfied or dead. We don't stand for no nonsense.

MMM. We?

POR. Yes. We, the good people of the kingdom. We don't complain. We like things the way they are. Those so-called rebels are all criminals, killing and pillaging in the name of freedom. If they don't like it here, they can go elsewhere. Love it or leave it. The good people of this land are sick and tired of the antics of a radical and malicious minority. May they all rot in peace.

MMM. Well said. But we're here about the party.

POR. How do you know about the party? It was just planned moments ago.

MMM. Word gets around. Anyway, a party needs entertainment, and we are the greatest entertainment this side of the world. We know how to make a party, *party*.

The MMM chants "party" and dances about, exhorting the servants to join in the fun. They do, and for a few moments, they forget their tasks and party, until the Porter is able to quiet them down.

POR. Wait one cotton-pickin' minute! (*To servants*) You people better git back to work 'cause I'll tell Miss Macbeth on you.

The servants hurry up and work.

POR. (*To MMM*) And you players will have to ask milady if you can entertain or not. She's in charge of the affair.

MMM. Take us to her.

POR. She's busy right now. She and Lord Macbeth are conferring with the king. I'm sure they do not wish to be disturbed.

MMM. You're right. We'll just get our stuff and set up. She can formally hire us later.

> *MMM exits.*
> *The Porter follows, protesting.*

POR. But . . . now, hold on . . . You just can't . . .

> *The Old Chamberlain and the Young Chamberlain enter.*

OCH. This place has changed quite a bit since I was last here. My memory of what was is now gone.

YCH. When were you here before?

OCH. Don't you remember? Oh, no. That's right. You weren't even born yet. But you were a twinkle in my eye. Here is where I met your mother.

YCH. Here? In this very room?

OCH. Yeah . . . uh, I'm not sure . . . No, I don't think so. This room used to be . . .

> *The Porter enters. Sees OCH.*
> *They stare at each other. Finally.*

POR. So after all these years, you've come back, Cecil.

OCH. Hello, Dewey.

POR. What do you want down here?

OCH. The king's things.

POR. They're where you left them. (*Indicates a pile of trunks and valises.*)

POR. I see you've come up in the world. From gofer to king's chamberlain.

YCH. Hi, I'm—

POR (*interrupting*). I know who you are. Dolores's son. I see the resemblance.

OCH. And I'm his father. (*Threatening.*) If you mess with him, I'll cut you until you disappear.

POR. Don't let your mouth make debts your behind will have to pay for. Biggest mistake this kid's mother ever made was to throw me over for the likes of you.

YCH. You knew my mother? POR. Yeah.

YCH. What was she like?

POR. Dolores? She was beautiful. I used to sing to her. (*Sings*). How I love the kisses of Dolores. Ayayay, Dolores, not Marie or Emily or Doris. Just me and my Dolores. (*Speaks*). She was vital. And obviously no taste as far as men were concerned.

OCH. She never liked you. Hell, you were old and senile *then*.

POR. Who are *you* calling old? Me? Boy, you're so old you should sleep in a coffin.

OCH. Oh, yeah? You're so old you were the assistant doorman in the garden of Eden.

POR. Why don't you die so that I can be the ugliest man in the land? OCH. Right. You're already the oldest.

POR. (*To YCH*) Son, you got one thing in your favor. You don't look like your father. God is merciful. (*Laughs.*) OCH. (*To YCH*) Come on, boy. We got work to do.

They go to the pile.

YCH. Is he a friend of yours, Dad?

OCH. Yeah. The only person I can rely on to be my enemy. (*He picks up a single piece.*) I'll take this, and you bring up the rest of the stuff. Do you remember where King Duncan will be sleeping?

YCH. Yeah.

> *The OCH exits.*
> *The YCH picks up as many things as he can carry and exits.*
> *The Kitchen Maid enters and calls to the Porter.*

KM. Ooooh. Who was that good-looking fellow? The young one?

POR. What do you care? You belong in the kitchen, not out here throwing yourself at strange guys. What's wrong with the guys from here?

KM. Like who? POR. Like me.

> *The KM laughs.*

POR. You laugh. But I'm still a good man.

KM. You may be a good man, but you're not the man for me.

POR. Why? Because of my gray hair and wrinkles? Hah. Don't let these things fool you. They're just camouflage to keep the old ladies away. I like my women like you—ripe, full, and sweet smelling. An old lady can't do nothing for me except have daughters. I want you.

KM. Well, I don't want you. I want a young man.

> *She exits.*

POR. (*Projecting after her.*) Only fools drink new wine! (*To self*) If I can't have you, then nobody will. This is one dream I won't let nobody take away.

The MMM appears.

MMM. (*To POR*) How badly do you want her?
POR. The devil don't miss a thing. (*To MMM*) Can you get her for me?
MMM. Sure can.
POR. Just like that, eh? Hmph. You young people . . . you think you are so super powerful. Just wait until you get old.

He exits mumbling to self.

MMM. Whatever is fair . . . or foul. Heh, heh.

The YCH returns to get the remaining baggage. He stops to talk to the MMM.

YCH. Hi.
MMM. Hi. Hie. High.
YCH (*incredulously*). You guys are *players*!
MMM. (*Mockingly*) No! (*Normal tone*) Do you play?
YCH. No. I'm just a chamberlain. My dream is to be a singer.
MMM. How badly do you want to sing?
YCH. I want to sing so bad I would . . . I don't know . . . I just want it.
MMM. How would you like a recording contract?
YCH. I'd love it.
MMM. We might be able to put you together with the right people.
YCH. Really? What do I have to do?

MMM. Hang on. We gotta hear you sing first.

The Porter enters.

MMM. Sing. Don't just dream. Sing.
POR. (*To YCH*) You're gonna have to keep working, boy. Get those bags out of here.
MMM. (*To POR*) Cool your heels, Granpa. The kid wants to sing. And we want to hear him.
POR. Y'all stay out of this. I don't have to take no lip—

The MMM "zaps" the Porter.

MMM. Relax.

The Porter calms down.

MMM. (*To YCH*) Sing.
YCH. What should I sing?
MMM. Sing "Pretty Maiden." Everybody knows that.

The YCH sings without music.

YCH (*sings*). Oh, pretty maiden. Will you love—

The MMM interrupts.

MMM. Stop! You need music.

The MMM gestures.

> *Lights come up on musicians.*

MMM. (*To YCH*) Now sing.

> *The YCH sings.*
> *During the song, the Kitchen Maid and the other servants appear and sing and dance. Even the Porter joins in.*

YCH. Oh, pretty maiden. Will you love me tomorrow like you do tonight? Hey, pretty maiden. When the morning comes, will you still hold me tight?
I know the kiss you give me don't mean a thing. But I'll take it, pretty maiden. I'm starved for love. I know when you hold me it's only for a while.
That's okay. You're a blessing from above.
Oh, pretty maiden. Will you love me tomorrow like you do tonight? Hey, pretty maiden. Will we walk hand in hand in the sunlight?
I know I'm just another heart for you to break. Another fool, pretty maiden, for your chain.
I know this crazy passion can only last so long. I don't care, pretty maiden. Drive me insane.
Oh, pretty maiden. Love me now. Tomorrow is out of sight.
Hey, pretty maiden. One kiss from your lips and everything is all right.

> *As the song ends, the OCH enters and sees his son singing and frolicking with the others. He yells.*

OCH. Hey! Hey! Heyyyyyyy!

The fun stops.
The YCH grabs the bags and hustles past his father who takes a swing at him.
He ducks and exits.
The OCH stares at the Porter and pulls out his dagger. The Porter unsheathes his dirk. The servants react with fear. The MMM chants.

MMM. Who's gonna cut who? Tell me whatcha gonna do?

The tension builds.
The OCH cleans his fingernails.
The Porter picks his teeth.
Nothing happens. The MMM tires of the standoff, stops chanting, and sends the OCH away with a gesture. The OCH backs off the stage.

POR. I always knew I was the better man.
MMM. Oh, nonsense. We sent him away.
KM. How did you do it? I didn't hear you say anything or see you do anything.
POR. *They* didn't do anything. My *pig sticker* sent him away.

The MMM gestures.
The Porter pricks his tongue with his dagger.

POR. Ouch!
MMM. You shouldn't talk and pick your teeth at the same time. Might cut your tongue.

The servants laugh.

MMM (*chanting*). Who's gonna cut who? Tell me whatcha gonna do?

End of Scene One

ACT ONE, SCENE TWO

CORRIDOR

Macbeth and Lady Macbeth enter.

LM. When Duncan is asleep—his two chamberlains will I with wine and wassail so convince that memory, the warder of the brain, shall be a fume, and the receipt of reason a limbeck only: when in swinish sleep their drenched nature lies as in a death, what cannot you and I perform upon th' unguarded Duncan, what not put upon his spongy officers, who shall bear the guilt of our great quell.

MCB. When we have marked with blood those sleepy two of his own chamber, and used their very daggers, that they have done't?

LM. Who dares receive it other, as we shall make our griefs and clamor roar upon his death?

MCB. We will proceed no further in this business: I am not going to kill Duncan.

LM. Why not?

MCB. Because he is the king and my cousin.

LM. Duncan shall never the morrow see.

MCB. He's here in double trust: First, as I am his kinsman and his subject, strong both against the deed; then as his host, who should against his murderer shut the door, not bear the knife myself.

LM. Tell the truth. You're afraid of him.

MCB. I am not.

LM. You are so. (*Chiding.*) <u>Yet do I fear thy nature. It is too full of the milk of human kindness.</u>

MCB. That sure is cold.

LM. What are you going to do about it?

MCB. <u>He hath honored me of late.</u>

LM. He's bigger.

MCB. I now bear two titles.

LM. He's stronger.

MCB. This last war has multiplied our riches.

LM. He's all man.

MCB (*grabs LM*). <u>Prithee, peace!</u> This is *me*, baby! Macbeth! More man than most men and less man than none. <u>I dare do all that may become a man. Who dare do more is none.</u>

LM. <u>What beast was it then that made you break this enterprise to me?</u>

MCB. <u>If we should fail?</u>

LM. <u>But screw your courage to the sticking place, and we'll not fail.</u>

BANQUET HALL

The victory celebration is underway.
The entire cast in onstage; Duncan leads the lunacy. Macbeth and Lady Macbeth enter and join in.

MMM. Ain't no turning back!

DUN. Ain't no turning back!

MMM. Come on. Let's escalate! CAST. Escalate! Hey! Hey! Hey!

All sing and perform "Escalate."

Escalate. Hey, hey, hey, hey. I got my shhh, and I'm waiting on you. Hey, hey, hey.
Kill and hate. Hey, hey, hey, hey. I got my shhh, and I'm waiting on you. Hey, hey, hey.
You get me, or I'll get you. We got to intimidate our way on through this life.
Maim and annihilate. Hey, hey, hey, hey. I got my shhh, and I'm waiting on you. Hey, hey, hey.
We're gonna escalate! Hey, hey, hey, hey. I got my shhh, and I'm waiting on you. Hey, hey, hey.
Gouge, kick, bite. Scratch, spit, stomp. Slap, stab, shoot. Romp, romp, romp. Yo-o.
Escalate! Hey, hey, hey, hey. Kill and hate! Hey, hey, hey. Come on. Now, escalate. Hey, hey, hey, hey. Maim and annihilate. Hey, hey, hey.
Escalate! Escalate! Escalate!

> *The song ends.*
> *There is laughter and merriment.*
> *Macbeth leads the partyers in a rousing salute to Duncan, which soon becomes unruly.*
> *Duncan signals Macbeth that he wishes to speak. Macbeth signals for quiet.*
> *His signal is unheeded. He tries again.*
>
> *Is unheeded. He screams.*

MCB. Shut the —— up!

> *Everybody gets quiet.*

Macbeth scowls at the unruly partyers.

DUN. (*To MCB*) Can't you control these idiots?

MCB (*apologetically*). They are not usually so, my liege. I'm sure it is the victory which has filled them with uncontrollable joy.

DUN. Yeah. It may be so. (*To all*) Nothing beats war to find out who your friends are. And I know that tonight, I am among friends. For all of you, at some time or other during the fighting of the past few days, have put your lives on the line for me. You showed yourselves to be loyal and true. I thank you. Each of you shall be rewarded.

Cheers.

MCB/PARTYERS. Hail to Duncan. Hail! Hail!

> Others join him. As they continue to sing, he signals for the Kitchen Maid to bring him the "king's pitcher," an oversized mug by any standards. It resembles a small keg with a handle. It has Duncan's graffiti all over it: "Badass," etc.
> It is filled to the brim with warrior's ale, a drink too strong for women and civilians.
> Macbeth takes the rude brew from the Kitchen Maid and presents it to Duncan. Silence.
> Duncan takes the pitcher from Macbeth and takes it up to his lips and chugalugs its contents while Macbeth leads the partyers in a "go" chant, which builds into a wild, climactic cheer, as Duncan empties the pitcher without stopping.
> Macbeth leads the partyers in a fervent rendition of "For He's a Jolly Good Fellow." He doesn't notice that Duncan

clutches his stomach and doubles over in pain until after almost everyone else has stopped singing and watching Duncan writhing in agony.

DUN. Poison.
MCB. Poison?

He quickly points an accusing finger at the Kitchen Maid.

MCB. You!

The Kitchen Maid protests weakly.

DUN (*a la dying breath*). Mac . . . b-b-beth.
MCB. Mac Who?

All eyes focus on Macduff as he rises up and advances menacingly on Macbeth, who backs up as he calls for Duncan to save him from having to fight. Just as a fight seems inevitable, Duncan sits up and laughs. Macduff laughs, the partyers laugh, and Macbeth collapses in relief. He recovers and joins the laughter.

DUN. I gotcha! Hahahahahaha!
MCB (*laughing*). Great joke, cuz.

He begins singing "For He's a Jolly Good Fellow."

End of Scene Two

ACT ONE, SCENE THREE

DUNCAN'S CHAMBER

> *The Young Chamberlain busies himself making a fire in the fireplace under his father's watchful eye.*

YCH (*singing*). Hey, pretty maiden, will you love me—
OCH. Hurry up with that fire.
YCH. I'm doing the best I can.
OCH. Close your mouth. Maybe you'll do better.
YCH. Didn't you ever want to sing?
OCH. No! Yes. To your mother. God rest her soul. Here, I'll get that fire going. The king will have us both flogged if this chamber isn't warm.
YCH. Did you?
OCH. What?
YCH. Sing to Mom? OCH. Nope.
YCH. Why not?
OCH. Never mind. (*OCH has built a good fire.*) Now . . . how's that for a fire?
YCH. Hot.
OCH. Cut the cute stuff. That's how you make a fire for a king. Put another faggot on.

> *YCH puts wood on the fire.*

YCH. Didn't my mother like music?

OCH. She loved music. Put the bucket for the footbath over the fire in a few minutes. And where are the bed warmers? Don't just stand there! Do something.

YCH sits on the bucket for the footbath.

YCH. Nothing to do.

OCH. There's always something to be done . . . Where's the bucket for the footbath?

YCH. I'm sitting on it.

OCH. Is that where it belongs? Under your arse?

YCH. Right now.

OCH. Put it in its proper place. It's not a chamber pot. Aha! Where is it?

YCH. Where it belongs.

OCH fetches the chamber pot.
Inspects it.

OCH. You know, son, this ain't such a bad life. Not everybody can be a king's trusted servant.

YCH. Big deal.

OCH. Yes, it is a big deal. Better than being a vagabond. We belong. We stand for something. We have a tradition.

YCH. That's dead.

OCH. Put the bucket over the fire.

YCH complies.

OCH. We enjoy royal protection. There is no better refuge save God's love. If it weren't for that, we would be like the rest of the peasants out there—starving to death. Son, the only way to never go cold and hungry in this world is to stay close to those who have the money and the power. Your mother never understood that. That's why I am trying so hard to get you to understand it.

YCH (*bored*). Yeah, yeah. I know. I know.

OCH. Go keep an eye on the banquet hall. And hasten to warn me when our lord takes his leave to retire.

> *YCH exits.*
> *OCH yells after him.*

OCH. And stay away from those damned entertainers.

> *OCH sighs.*

OCH. Ah, Dolores, my sweet Dolores. Here I am again in the place where we first met. How do you like our son? I didn't do such a bad job, did I? For raising him by myself, I think I did okay. He's gonna be all right. He's still young, got the fire of life in his skivvies. Maybe it's time he got married. Make a man out of him. Made a man out of me. Oh, Dolores. Why did you have to leave me? I need you so much. (*Sings.*) You are the song I sing when no one is listening.
You are the thought I never share.
You are the peace that is always with me.
You are the love I hide with care.
You are my secret melody.
Sweet tune of memory.
The rock of my heart. The rhythm of my soul.

The blues in my life. The ball in my roll.
Your words make me shout.
Your beat makes me dance about.
You are the purest sound I've ever known.
Sing me, song. Keep me loving all life long.
Play me right or play me wrong.
You are my reason. And my love.
You are my promise from above.
The hope that I cherish when I am alone.

Repeats first four lines.
The song ends.

End of Scene Three

ACT ONE, SCENE FOUR

BANQUET HALL

> *Banquo takes Macbeth to the side. The party goes on in the background.*

BAN. Macbeth, who are those entertainers?

MCB. Why do you ask?

BAN. I got a funny feeling I've seen them somewhere before.

MCB. Maybe they entertained at one of your parties.

BAN. No. I don't think so.

MCB. Well, I certainly don't recognize them. Anyway, my lady hired them. You'll have to ask her.

BAN. I know! Remember those creatures at the heath?

MCB. No!

BAN. Sure you do. Those unearthly-looking creatures—

MCB (*interrupting*). You mean those unreal figments of our battle-weary imaginations?

BAN. But what they have predicted has come true. You got promoted to the rank of Thane of Cawdor.

MCB. They also predicted that I would be king. And that hasn't happened yet. Hah! I figure it was all just a coincidence, and those alien forms we encountered were only the ghosts of all who we had that day dispatched to hell.

BAN. I don't know. Something about those weirdoes gives me the creeps.

MCB. Why don't you just party and forget about what happened out there on the heath?

BAN. You're right.

MCB. Of course, I am. Excuse me, friend.

MCB exits.
BAN rejoins the party.

DUN. Hey, Lennox.

LEN. Sire?

DUN. Do you remember that bloody sergeant?

LEN. Nay, my liege.

DUN (*funning*). Sure you do. The one with the big hole in his neck, bleeding like a stuck pig. Didn't you write a poem about him? (*To others*) Lennox poetizes everything. You guys should have been there. That sergeant was a valiant warrior—a real kick-ass dude. (*To Lennox*) Wouldn't you say so, Lennox? How do you say that in poetry?

LEN. War doesn't inspire me to poetry, my king.

DUN. Don't inspire you to much else either.

No response from Lennox, who is getting sick.

MACDUFF. (*To Duncan*) Remember the war before this one, milord? The bowman who got his neck broken in the final battle? He had to use one hand to fight and the other to hold up his head.

They laugh, having a good time.

DUN. And that other guy who caught a spear in the eye. Ugh! (*To Lennox*) This is the real world, Lennox. You got to be tough to survive. Poets don't make it.
LEN. Tough? Why? Where's the thrill in killing?
DUN. In knowing that you have the power to stop life if you choose. The trick is to make the other guy miss a breath before he stops yours. Hahahaha!
LEN. What if he stops yours first?
DUN. That's the chance you take. Hahaha!
LEN. Mine eyes fail to see the fun—
DUN (*interrupting*). Shut up!

He knocks Lennox to the floor.
Banquo crosses to Lennox as if to console him.

BAN. Your first time in battle, Lennox?

Lennox, fighting the urge to upchuck, nods yes.

BAN. I remember my first time in battle. So much blood, the ground was muddy red. Corpses everywhere. Couldn't see the sun. Bodies were stacked so high.
LEN. Excuse me, my liege and gentle sirs.

He gets up from the table.

DUN. You're not excused. Sit!

Lennox sits.

DUN. I remember when I lost my cherry. There was blood everywhere.

> *Duncan and the others laugh.*
> *Lennox heaves.*

DUN. (*To Lennox*) Now you're excused.

> *Lennox leaves the table running.*

DUN. (*To others*) If he can't take it, screw him.

> *The others laugh.*
> *Duncan passes out.*

LEN (*sings*). When will I get used to war?
All the blood? All the mud? All the gore? When will I learn to love strife?
Taste of death? Enemy breath? Kill for life?
Will I ever be able to waste a man without getting sick after it's done?
To embrace a comrade who has just slit a throat, and pretend I'm having fun?
What do I stand to gain or lose?
Not a thing. Everything. I'm confused.

> *He chokes on sick feeling.*

(*Speaks.*) I'm trying.

> *He exits.*

Duncan revives. He is raving drunk.

DUN. I showed those sons of bitches. Let that serve as an example to all who dare defy me. I will stamp out rebellion wherever it exists. No one is going to usurp my rule. No one. I'll use his head for a candleholder.

He passes out again.
Macduff and Banquo attend to him.
YCH goes to warn his father.

MACD. (*To Duncan*) Aw, you're just an old softie.

Duncan rises up.

DUN. Old softie, am I? (*Laughs.*)
MACD. You old faker.
DUN. You thought I was sleeping, eh? Hah! I wasn't sleeping. I was just remembering the first time I got laid. I was eleven years old. Do you remember that, Duffy?
MACD. How could I forget? It was my first time too. One of the maids in your father's castle. What was her name?
DUN. I don't know and don't care. All I remember is the colors of them undies.
MACD. Yeah. Heh, heh.
DUN. Remember how she used to take us up to the tower and show us her safety deposit box?
MACD. Yeah. And all the time, we thought she was just showing it to us. Come to find out, everybody in the castle was banking with her.

DUN. We done had some good times together, ain't we, Duffy? (*Indicates the Kitchen Maid.*) Hey. This little wench here kinda looks like old whatchamacallit, don't she?

MACD. Sure do. I wonder if she wears rainbow drawers.

DUN. Let's find out.

> *Duncan winks to his companions.*
> *They decide to have some fun with the Kitchen Maid.*
> *They sing the following song while they "tease-rape" her.*

DUN/MACD/BAN (*singing*). She had on those multicolor panties that I knew so well.

The ones she used to wear when we played show and tell.

I watched her through the keyhole with the man who had taken my place.

She was leading him on a merry, merry chase.

And I cried when he caught her just like I used to do.

I even felt more heartsick when she told him "I love you." As his hand stretched the elastic, she didn't try to get away.

DUN/MACD/BAN (*singing*). I closed my eyes in sorrow. I couldn't watch the game I used to play.

Multicolor panties, show me the treasure that you hide. If I can tell you what it is, will she take me for a ride?

Multicolor panties, guard of my ecstasy.

I thought I was the only one who had the key. To your vault of love and sweet fantasy.

But that hand pulling you down don't belong to me.

> *The song ends.*

Duncan and his cohorts have a good laugh on the Kitchen Maid and then exit.
The Porter, who has witnessed the whole thing, approaches the Kitchen Maid.

POR. I sure wouldn't have teased you like that, baby. Heh, heh.
KM. Oh, shut up, you old fool!

She exits crying.

POR (*derisively*). Youngster.

MM appears.

MMM. (*To Porter*) Do you still think you can get her by yourself? You need help.
POR. Okay. Help me.
MMM. Only if you do as we say.
POR. Deal. But wait a minute. What do you get out of it? MMM. Fun.

MMM exits laughing.

End of Scene Four

ACT ONE, SCENE FIVE

DUNCAN'S CHAMBER

> *The inebriated trio—Duncan, Macduff, and Banquo—enters the chamber singing and joking.*
> *The OCH and the YCH go into their act: undressing and washing his lordship.*

BAN. Sleep well, milord.
DUN. I always do. Like a baby.

> *Banquo exits.*

DUN. (*To MACD*) That Lady Macbeth really knows how to throw a party. I wish we didn't have to leave tomorrow. I could stay here and party for a week. But . . . I gotta stamp a whole slew of decrees. Order some more executions. Damn those rebels! If they only knew all the paperwork involved in an uprising. That's the only part about being king that I don't like.
MACD. Git some sleep. You'll feel better in the morning. DUN. Last one up rides an ass to my castle.
MACD. I shall have showered and shaved by the time you get up, dude.
DUN. Bet.
MACD. Bet.
DUN. We'll see who wakes who.

MACD. I shall call timely.
DUN. By then your king will be gone.
MACD. Where my king goes, go I.

>*Duncan snores.*

MACD: Sleep well, great lord. I love you.
DUN (*laughs*). Do you really?
MACD. You ol' faker. (*Laughs.*) I'll see you in the a.m.

>*Macduff exits.*
>*YCH puts Duncan's foot in the footbath.*

DUN. Ow! Imbecile!
OCH. Is it too hot, milord? (*To YCH*) Boy, I thought I told you not to let that water get too hot?
DUN. Get your untrained idiot whelp of a son away from me!
YCH. Begging Your Majesty's pardon.
DUN. If a fish had your brains, he'd either die or swim backwards.
OCH. Is the room warm enough for my liege?
DUN. Get out, cuckold! And take your bastard with you. Ha! I remember your mother well. Dumpy little broad with massive mammary glands. She was a nightmare. Fit only to ride when the moon eclipsed itself.

>*Duncan passes out.*
>*The OCH motions for the YCH to be still and wait. Duncan might not be sleeping. The OCH tucks Duncan in.*
>*Then, he motions to YCH and in unison they say,*

OCH/YCH. Good night, good king Duncan, sir.

> *They move noiselessly. The OCH gets the chamber pot and motions for the YCH to fetch the king's cape. They exit.*
> *The Magic Mind Monster appears and makes a gesture that causes the sleeping king to rise and sleepwalk.*

End of Scene Five

ACT ONE, SCENE SIX

BANQUET HALL

Lady Macbeth enters with Macbeth.

MCB. <u>My dearest love</u>.
LM. Am I your dearest love? It seems to me that war is your dearest love.
MCB. You know better than that, baby. War is necessary to keep the peace.
LM. Peace where? Out there maybe. What about here where you live? Don't you care about the peace at home?
MCB. I sure do, hon. I love you.
LM. What does your love mean when you're never at home? But off fighting somewhere and risking your life for Duncan's glory. And I'm here all alone. (*Sings.*)

> If I were the man you say you are
> So much in love with my wife
> I'd put her first just once in a while.
> If I were the man you say you are
> I'd go that extra mile
> I'd take that extra step.
> If I were the man you say you are
> I'd give her a flower, a smile, or maybe even a crown.
> Kill for me like you kill for Duncan.

Kill for us! Kill for us!
Kill for me like you kill for glory.
It's time you killed for your own.

The MagicMindMonster joins in singing the "Kill for Me" chorus. The chorus crescendos, taking away Macbeth's strength. He falls at Lady Macbeth's feet.

MCB. All right! <u>I am settled and bend up each corporal agent to this</u> <u>terrible feat</u>. (*Catches his breath.*) I'll make you queen of Scotland, queen of the world, queen of the universe. (*Catches breath.*) Just call off those insane forces.

MCB (*sings*). We've got to hide our intentions. No one must ever know. We've got to kill our emotions. Our deceit mustn't show. We've got to grin and bear it. Put on a happy face.
Keep a sparkle in our eye. We must never seem out of place.

LM (*sings*). We've got to be extra careful. They say that walls have ears. We've got to watch how we act. Give no reason to their fears.

MCB (*sings*). We've got to think every second. See from behind our masks.
Keep a bounce in our step. We must never betray our tasks.
And when it's all over, the world will be ours.
We'll be rolling in clover. The world will be ours. I've made up my mind. The world will be ours.
I love you for all time. The world will be ours.

LM (*sings*). We've got to keep a low profile. Go on with the play.
We've got to overcome the obstacles that get in our way. We've got to be natural. There can be no surprise.
Keep control of our feelings. We must never be caught in lies.

Macbeth and Lady Macbeth sing together and dance.
From offstage, a bell strikes twelve times.

MCB. <u>Away, and mock the time with fairest show: False face must hide</u> what the false heart doth know.

Macbeth and Lady Macbeth exit.
The Kitchen Maid returns to finish her chores. The pregnant girl is with her.
The Porter returns from having shown Macduff out.

KM. I'd sure like to meet that gorgeous hunk of man.
POR. Around here, there is only one guy who fits that description.
KM. Do you know who I mean?
POR. Sure. We grew up together.
KM. What's his name?
POR. Me.
KM. Stop fooling around.
POR. Okay, my dear. What can I do you for?
KM (*sings*). There's a handsome young man. He's the king's chamberlain.
I've a feeling he's secure. He is tall and mature.
His eyes are happy pure. I'd give the world to hold his hand. I pray thee, please help me. I want to make him mine.
Please ask him to meet me. Oh, he is so fine.
His eyes are happy pure. I'd give the world to hold his hand.
He's got a strong chin. A charming, jolly grin.
I've just got to know his name. I can't help it.
My heart is to blame.
His eyes are happy pure. I'd give the world to hold his hand.

End of the song.

POR. Don't you want to practice your moves first? I can give you a few pointers.

KM. I'm serious.

POR. I know, child. Young love always is. Where do you want to meet the guy?

KM. Here.

POR. Okay, I'll tell him.

She kisses him on the cheek and exits.

POR. (*To self*) What am I doing helping her to get him? That ain't advancing my cause. I don't even like that kid. His father stole my girl.

MMM appears.

MMM. Like him. POR. Do I have to?

MMM. Do you want the Kitchen Maid? POR. Yeah.

MMM. Like him.

Porter exits grumbling.

MMM (*yelling after him*). And remember . . . be nice!

End of Scene Six

ACT ONE, SCENE SEVEN

CORRIDOR OUTSIDE DUNCAN'S CHAMBER

The OCH and the YCH enter.
OCH hands YCH the chamber pot.

OCH. Dispose of this.
YCH. Where?
OCH. Hold it until you figure it out, gnatwit.
YCH. Hey, Pops. Gimme a break.
OCH. Shhh. You'll wake the king.

Duncan enters sleepwalking.
OCH guides him back into the chamber without waking him.
He returns to YCH.

OCH. Boy, you gotta learn. Caring for the king ain't easy.
YCH. Who you tellin'?
OCH. I'm not gonna always be here to take care of him. My days are runnin' out. I'm gettin' short. Time be up soon.
YCH. Promises. Promises.
OCH. Watch your mouth. I ain't so old that I can't knock you out.

He goes into a fighting stance.

YCH. Okay, Dad. I was only funnin' . . .

The Porter enters.

OCH. (*To Porter*) What do you want?
POR. Nothing with you. I got a message for the lad here.
YCH. For me?
POR. Yeah. From that saucy little chickee in the kitchen. (*To OCH*) What is it with you king keepers? Every time you come around, the women go nuts.
OCH. Quality, my good man, quality. After all, they deserve the very best.
POR. Never would know it by the guys they choose. (*Sniffs.*) What's that smell?
OCH. Your upper lip.
YCH. The king's comfort. I don't know where to get rid of it.
OCH. He doesn't know the layout of this castle.
POR. You do.
OCH. I ain't no honey bucket boy.
POR. You were when your father was alive. He was a hard-ass.
OCH. Related to your grandmother.
POR. Where did you hear that?
OCH. Here. When I was a kid, she was the head cook. Daddy called her cousin Jemima. Used to send me after the king's pancakes.
POR. That don't prove nothin'. If they had been family, Gramamima would have made me call him Uncle Ben. And I never had to. Don't you be trying to mix your blood with mine just because our families go back in time together. We serve different masters.
YCH. Will y'all hep me to what's happenin'? I just got here. You're both slavin' and got nerve to be proud of your yokes.

POR (*with admiration*). You're Dolores's son, all right.

OCH. Keep your lips off of her name.

POR. I don't have to. I loved her.

YCH. Wait a minute! Can't you old men do something else besides rerunning your lives before me? I wasn't there. Y'all were. All I want to know is, where do I dump this crap I'm holding?

OCH. Shut up, wiseass . . . Don't get smart. Yeah, we're old men because we survived. We weren't like you kids today. We respected our elders.

POR. Aye, that we did.

OCH. We did as we were told. Children are to be seen, not heard. Spare the rod and spoil the child.

POR. Yep, that's the way it was.

OCH. Wasn't no such thing as a young'un talkin' back to a grown person. Or if we were caught doin' wrong, they whipped you, and then you got another whipping when your real parents found out.

POR. Yeah, those were the good old days.

OCH. Yes, they were. Kids didn't act and talk all out of their heads when we were young.

POR. What do you mean when we were young? You were young before me. When I was a young'un, you were one of the bad older boys. Always gittin' whupped about somethin'.

OCH. Yeah. Our folks believed in breaking your spirit.

POR. And yet Dolores couldn't be broken. (*To YCH*) Speaking of unbroken spirits, that little kitchee chickee is waiting. Do you like her?

YCH. I don't know.

POR. You like her. The stench of that pot bothers you not. Only love can transform offal aroma into perfume.

OCH (*laughs*). Boy, you oughta quit.

POR. Am I lying? (*Laughs.*) (*To YCH*) She wants to meet you in the banquet hall. I'll show you where to take care of the king's business.

OCH. Just keep your cloak on your haunches, or you'll freeze your buns off.

POR. He don't have to worry about that. That gal looks like she'd make the devil overheat. That fill is healthy and ready. Reminds me of—

OCH (*interrupting*). I was just thinking the same thing.

They laugh together.

POR. (*To YCH*) Come on, lad.

The Porter and the Young Chamberlain exit.

OCH. Dolores, did you hear that? A girl is interested in our son. It's like history repeating itself. Oh, Dolores, my whole being aches for your touch. I wish I was with you.

MMM appears.

MMM. Hey, Old Chamberlain, do you want to make a deal?

OCH. What's the deal?

MMM. You let your son be who he chooses to be, and we guarantee you will join your wife.

OCH. Do you know where she is?

MMM. Of course.

OCH. You got a deal.

MMM. My, my. So quick? Don't you want to haggle?

OCH. I can't stand the pain that much longer. It's been years since I saw my baby's eyes. Life can't do me much wronger. Mystery is no surprise. Lead me to my true love. Take away this pain.
MMM. Free your son.

The MMM disappears.

The OCH is momentarily astonished, but then he shrugs his shoulders and starts on some small chore.

End of Scene Seven

ACT ONE, SCENE EIGHT

BANQUET HALL

The Porter and the YCH enter.

YCH. Dad never talks about Mother to me. Would you tell me about her? I need to know her. I never had a chance. She died a few months before I was born . . . I mean . . . after I was born.
POR. Who told you that?
YCH. Dad. He told me that she never recovered from giving me birth.
POR. He blames you?
YCH. Not exactly. But sometimes when he looks at me, I feel like he wishes I had never been born.
POR. If she had married me, you would be my son . . . but she loved your father.
YCH. Do you hate my father?
POR. Naw, I thought I did. It don't matter. Never really did.
YCH. I hate him.
POR. Why?
YCH. He's always on me about somethin'. Do this, do that. Shut up. Blahblah. I hate being a chamberlain.
POR. Why? It's a good job. Plenty of security.
YCH. Yeah. That may be so, but I see how alone he is and how he has to bow and scrape.

POR. Boy, his bowing and scraping has fed you and kept you alive all these years.

YCH. I understand that, but there has to be another way. One of the things I've discovered about myself is that I don't want to go through life just struggling to survive. I want something more. (*Sings.*) Discoveries of myself are happening every day. I'm watching the time fall away. I see what I am and what I used to be. It's such a thing to see. And then I laugh. And then I cry. And then I jump up and down.
I roll myself all over the ground.
I wanna dance a tune or kill myself. Oh, my goodness. Is this what I am?
I talk about myself like a dirty dog. I wallow with myself like a stinkin' hog.
Discoveries I make every day. I'm watching the time fall away.
I love myself to death sometimes. Sometimes I hate myself to the same state.
And all the time I wonder why I have to love or even get off of some hate. Ain't it enough just living in this world, trying to make it until we die? Why we gotta fill the air with phony laughter while a lot of real babies cry?

The song ends.

POR. Come on, son. I'll show you how to come and go without disturbing the house.

He motions for the YCH to follow him. They exit.

End of Scene Eight

ACT ONE, SCENE NINE

CORRIDOR

The OCH is about his chore.
Lady Macbeth enters carrying the deadly potion.
OCH sees her.

OCH. Good even', milady.

LM. Good morrow to you, royal chamberlain. Doth the king sleep? OCH. Yes'm, he doth.

LM. Where is the other chamberlain? OCH. Tending to royal affairs, ma'am.

LM. Will you join me in a toast to your king?

OCH. Begging milady's pardon, but we are on duty, and as such are forbidden— LM (*interrupting*). Oh, humbug. This is no strange field of battle, loyal chamberlain. This is the house of Macbeth, the king's cousin. There is no need for silly precaution here. We are all family. Drink.

She holds out a cup.
The OCH takes it.

LM (*raising her cup*). To our king.
OCH (*raising his cup*). Brave Duncan. Sovereign of Scotland.

They drink.

LM. Do you find it strange that I am here?

OCH. Yes'm.

LM. Well, you really shouldn't be alarmed. I have always taken a personal interest in the welfare of all who enter my home. Whether they be lord or servant. After all, we are Scots, n'est-ce pas?

OCH. Aye, milady. The king himself calls you the most gracious hostess in all the land.

LM. To me.

> *She refills his cup.*
> *They toast.*

OCH. To thee, milady.

> *They drink.*

LM. To us.

> *She refills his cup.*
> *They toast.*

OCH. To us.

> *They drink.*

LM. Is he your son?

OCH. Milady?

LM. The other chamberlain. Is he your son?

OCH. Aye. But he wants to be a singer. Doesn't want to follow in my footsteps.

LM. And good help is so hard to find nowadays.

OCH (*tipsy*). Can't talk to these kids nowadays. They think they know it all. I tell him he should be proud of his heritage. Not everybody can be a chamberlain.

LM (*raising her cup*). To tradition.

OCH (*raising his cup*). Tradition.

He drinks.

M. Do you have any other children?

OCH. Nay, milady.

LM. Where is his mother?

OCH. She died before he was born . . . I mean, while he was still a babe. LM. I'm sorry to hear that.

OCH. Maybe *you* could talk some sense into him.

LM. What say ye?

OCH. The kid. He might listen to you. A woman like the mother he never had. Perhaps you can persuade him not to turn his back on his calling. If he does, the pride of service to gentle lords and gracious ladies dies with me.

LM raises her cup.

LM. To death.

OCH. Milady?

LM. Er . . . May it never die. The pride of service, that is. Long live it. OCH (*raising his cup*). Live it.

They drink.

End of Scene Nine

ACT ONE, SCENE TEN

BANQUET HALL

The Kitchen Maid enters. She has prettied herself up. After a few moments, the Young Chamberlain enters carrying the chamber pot. They smile and walk toward each other. As they get closer, they stop.

KM. (*Aside*) From faraway, he looks different.

YCH. (*Aside*) From faraway, she looks different. (*To KM*) What's happenin'?

KM. (*Aside*) He's shorter than I thought. (*To YCH*) What do you want to happen?

YCH. (*Aside*) She's fatter than I thought. (*To KM*) I'm down for anything.

KM. Can you handle it? (*Aside*) His eyes. Are they the color of my dreams?

YCH. (*Aside*) Her eyes. Are they the color of my dreams? (*To KM*) What it be like?

KM. (*Aside*) He's younger than I thought. (*To YCH*) Don't you know?

YCH. (*Aside*) She's plainer than I thought. (*To KM*) Yeah, I know. I want to see if you know.

KM. Of course, I know.

YCH. Prove it. (*Aside*) Her lips. Are they the color of my dreams?

KM. I don't have to prove nothing to you. (*Aside*) His lips. Are they the color of my dreams?

YCH. (*Aside*) She's okay. (*To KM*) You're right. I'm sorry. I didn't mean to hurt your feelings.
KM. That's okay. (*Aside*) He's more sensitive than I thought. (*To YCH*) I didn't mean to hurt your feelings.
YCH. That's okay.

There is a moment of awkward silence. Then

YCH. I gotta go. My father is waiting for me.
KM. Me too. I gotta make a big breakfast in the morning.
YCH. What's your name?
KM. Sookie. What's yours?
YCH. Junebug. I like you, Sookie.
KM. I like you, Junebug.
YCH. Do you have a boyfriend?
KM. No.
YCH. Neither do I . . . uh, I mean . . . I don't have a girlfriend.
KM. I have a dream man though.
YCH. I hope it's me.

She kisses him lightly.

KM. Maybe you are.

They sing.

KM/YCH. Your eyes are the color of my dreams. Your lips are the color of my dreams. Your hair is the color of my dreams. You are the color of my dreams.

Your smile is the color of my dreams. Your touch is the color of my dreams. Your love is the color of my dreams.

You are the color of my dreams.

You are the spectrum of my happiness. The prism through which I see my life. You are the hues of blissedness, the tint of rainbow's treasure vowed.

Paint me wonderful, dream. Gild me magic, moonbeam. Color my being, twinkling stream. The smile of sunrise.

Your heart is the color of my dreams. Your soul is the color of my dreams. Your life is the color of my dreams. You are the color of my dreams.

The song ends
They embrace.
The MMM appears. Gestures.
The action freezes.

MMM. (*To audience*) We'll be back after a brief intermission.

END OF ACT ONE

ACT TWO

ACT TWO, SCENE ONE

CORRIDOR

Lady Macbeth and the Old Chamberlain are frozen in position. MMM enters.

MMM. (*To audience*) Check Lady Mac out. She's rarin' to get on with the action. This is all so exciting to her. The thought of wearing the crown is arousing her erotic passions. All that jive about "unsex me here" she was talking about in the first act don't mean nothin'. She wants some lovin'. The child is hotter than dry ice. Let's see what happens.

MMM gestures. LM and OCH continue their scene. By now, OCH is silly drunk.

OCH. Death is only the stoppage of time for each person, milady. And time to me is an invention of man. When man is no more, time will be what it is—timeless. Heh, heh. My father used to say God has only one time—always.

LM. Your father was a wise man. Drink.

She refills his cup.

OCH. Yes, he was, milady. He also used to say—

The YCH enters carrying the chamber pot.

LM. Well. The prodigal returns.

OCH. Where have you been, boy?

YCH. I . . . er . . .

OCH. (*Interrupting*) Never mind. Give me that.

He takes the chamber pot. LM catches a whiff and raises her cup as if to toast.

LM. To mighty Duncan.

OCH. (*To YCH*) I'll put it in its proper place. The king does not yet know your step.

LM. (*To OCH*) Is he a light sleeper, faithful chamberlain?

OCH. Aye, milady. He can hear a mosquito pissing on cotton. Er . . . I mean . . . begging your pardon, gracious lady. Ooooh, this is some potent potable. Thank you kindly, ma'am.

He holds out the cup to LM.

LM. Let the boy toast.

OCH. This is highly irregular, milady.

LM. It is exemplary that you want to teach your son his place by observing every letter of the rule. But every rule has its exception. There is no need for suspicion or caution amongst kin.

OCH. Of course not, milady. No offense meant. (*To YCH*) Kid, toast Our Majesty and this house.

He gives the cup to YCH.

YCH. Right on.

> *He drinks.*

OCH. Idiot! You're supposed to toast first. (*To LM*) Please excuse his behavior, milady.
LM. Let it bother you not, loyal chamberlain. Why don't you conclude the royal business.

> *She indicates the chamber pot.*

OCH. Immediately, ma'am.

> *OCH exits with the pot.*

LM. (*To YCH*) Here, lad. Have some more.
YCH. I'm not accustomed to strong drink, milady.

> *LM pours wine into YCH's cup.*

LM. Oh, come now. Surely such a dainty drink couldn't do a thing to a mighty fella like you. Drink.

> *She raises her cup.*
> *YCH follows suit.*

LM. To the king.

> *YCH drinks.*

LM. To Scotland.
YCH. I drank all of mine.
LM. Have some more.

> *She refills his cup, toasts, and becomes seductive.*

LM. To us.

> *YCH drinks.*

LM. To everybody.

> *YCH drinks.*
> *She refills his cup.*

LM. To the world.

> *YCH drinks.*

LM. Your father tells me that you want to be a singer.
YCH. Yes, ma'am.
LM. Look. Right now, you don't have to call me ma'am or milady or anything like that. Tonight is a special occasion. There is no difference. We are all the same. Savvy?
YCH. As you wish . . . uh . . .
LM. Not only as I wish but as I command.
YCH. Okay, baby.
LM. Excellent. I used to be a singer.
YCH. Really?

LM. Yes. Years ago. More years than I care to remember. I thought it would be fun, but let me tell you. It's a hard life being a singer.
YCH. You were a singer? LM. Dare you doubt?
YCH. No, ma'am . . . milady . . . uh . . mama. LM. Drink.

She refills his cup.

LM. I was one of the background vocalists for Floozie Flo the Flapper. I'm sure you never heard of her. That was before your time. Hah! Isn't that something? I had all but forgotten about that wild, rebellious part of my life until just now. Isn't that something?

She laughs. YCH laughs.

LM. Sing me something. I can tell whether or not you have the stuff to make it. After all, I should know. Don't you think?
YCH. Most certainly . . . I . . . I—
LM. (*Interrupting*) Sing, then. Don't be afraid. Hell, sometimes we sang in places packed with people. Flo never let on how scared she was. She sang. Drugged out of her mind. Narcotics finally killed her. That's when I came to my right senses and gave up that miserable monkey-bearing life. But when she was high, oh, could she sing. This was her favorite song. (*Sings.*) People try to tell me that you just ain't no good.
If I would only give them the word, they'd run you out of the neighborhood.
But I don't let them 'cause it's the game I play.
Lie to me, baby. There ain't no other way.

I remember one fine day not too long ago. You broke down and told me more than I really wanted to know.

I got all upset. It nearly blew my mind. But I'm gonna give you one more chance and tell you one more time.

Lie to me, baby. Don't tell me the truth. If you can't do this one thing for me, I'm gonna have to cut you loose.

Lie to me, baby. Let me keep this fantasy. It may not be what's happening, but it beats the hell out of reality.

She speaks as she keeps rhythm.

While Flo was singing, we would be echoing her. Like "I want to play" or "No other way" or "One more chance" or "Keep this fantasy." And all the time doing a routine, you know, circles, splits, the works.

She goes into a routine.

Then we would end the song together with. (*Sings.*) Bullshit me, baby.

She ends the song with a pose.

LM. Whew! I need another drink after that. How about you, handsome?
YCH (*excited*). Lay it on me.

She refills his cup. YCH grabs her.

YCH. Wow! You git down, milady . . . uh . . . chick.
LM. Is that a gun in your pocket? Or are you happy I'm here?

The OCH returns from his chore.

The drug is slowly besting him.

OCH. The king is sleepwalking . . . sleeping like a cuckoo in a warbler's nest. He is at home here in Inverness, milady.

YCH. You don't have to call her milady, Dad.

OCH. Who? Milady? Mind your manners, boy. And give me that cup.

He takes the cup from YCH.

LM. It's all right, loyal chamberlain. I gave permission for the familiarity.

OCH. But he must stay in his place.

LM. Perhaps you are right. Let us drink one more toast to ourselves. Then I shall retire.

OCH. Please, milady. Don't think that I am not honored by your presence. If it will please thee, we will shine sleep on.

LM. Oh, never mind. You are no doubt exhausted from the excitement of the last few days. I too am beginning to feel the aftertaste of victory. Let us drink.

She refills the cup OCH has, gives another cup to YCH, and raises her own cup in a toast.

LM. To my king.

OCH. And may the gentle lord and lady of this house long reign in peace and tranquility.

OCH and YCH drink.

LM. Sleep well.

OCH. Boy, take these cups and wash them out.

LM. Don't trouble yourselves.
OCH. No trouble, ma'am.
LM. Give the cups to me. I'll take care of them.
OCH. Oh no, milady. This boy can—
LM. (*Interrupting*) I don't want to hear it. You are my guests in my domicile, and you will behave yourselves as such. Now give me the cups.

OCH gives her the cups.

LM. Now off to bed.

She exits.

OCH. Godspeed, milady. My life does long to rest.

YCH plops down on his cot.

OCH. Git up and say your prayers.
YCH. (*Sleepily*) Aw, fuh—
OCH. (*Interrupting*) What? What did you say?
YCH. Fun, Dad. I said, "Aw, fun."
OCH. I'm gonna teach you how to be a good servant if it's the last thing I do.
YCH. (*Mocking*) You're a chamberlain's son just like your father and his father and his father before him, and your son is gonna be a chamberlain. Chachacha.
OCH. Don't mock me, boy.
YCH. Dad, if I am forced to be something I don't want to be, then it will end with me.

OCH. What are you saying?

YCH. I am saying that I don't want to be a servant.

OCH. I guess you think you're supposed to be king.

YCH. No. I don't want to be king either. I want to be me.

OCH. Do you think you are too good to be a servant?

YCH. Ain't nobody said nothing about being too good.

OCH. Oh . . . your people's ways don't meet your approval.

YCH. Dad, I just want to be me. I'm not happy.

OCH. Happy? Hah! That's dangerous talk. Don't be naive. We are servants. Our burden in life is to suffer gladly in the name of He who rules all. We are his servants, and he commands us to serve others. Make them happy. We are free by reason of our servitude to the Almighty. Why do you want to be other than what you are? You sound like a rebel. You saw what our lord does to rebels. He chastises them mightily. They have nowhere to live, no food. They're starving to death. You saw them in those villages. And that ain't nothin'. Years before you were born, when I was a kid, some servants became outlaws and thieves. Their cry was freedom. They got caught and were tortured. We, the loyal servants, had to watch them die in painful agony, and then we had to swear undying allegiance; after all that, they still whipped us. Didn't matter that we wasn't in it. (*Threatening*) Before I let that happen to you, I'll kill you myself.

YCH. Kill me?

OCH. Yes! I'll kill you for your own good.

YCH. Dad, why did you bring me into this?

OCH. Into what?

YCH. Why was I born? You knew what this life was like. But yet you and Mama still had me. Brought me into this mess.

OCH. That couldn't be helped. We were in love.

YCH. Well, I'll never love.

OCH. What about the kitchen maid?

YCH. What about her?

OCH. Didn't you . . . ? (*Makes sexual body movements.*) You know what I mean . . . don't you?

YCH. Yeah, I know. And we didn't.

OCH. Must not make them like your mother no more. She met, made, and married me all at the same time. Messed my mind all up. (*Smiles with self.*) Maybe you'll find somebody to love one of these days.

> *He passes out.*

YCH. Maybe I already have.

> *He reprises "Color of My Dreams" from the bridge. From offstage, we hear the KM singing the same passage.*

YCH/KM. Paint me wonderful, dream. Gild me magic, moonbeam. Color my being, twinkling stream, the smile of sunrise.

> *The singing ends.*
> *YCH sleeps.*
> *Lady Macbeth returns to Duncan's chamber. Takes the sleeping chamberlains' daggers and lays them out.*
> *Exits.*

End of Scene One

ACT TWO, SCENE TWO

THE BANQUET HALL

> *The MMM is frolicking and chanting.*

MMM. Hail, Lady Macbeth. Hail to thee. Hail, Lady Macbeth. Hail to thee. Hail, Lady Macbeth. Hail to thee.

> *The chant ends.*
> *MMM gestures and disappears.*
> *Macbeth enters.*

MCB. <u>Whilst I threat he lives: Words to the heat of deeds too cold breath gives</u>.

> *He sits and dozes.*
> *The Porter comes out in his bedclothes.*

POR. Shush up, out here!

> *He sees Macbeth.*

POR. A thousand pardons, milord.
LM. (*From offstage*) Macbeth!

The Porter hides.
Lady Macbeth enters with the tray and cups.

LM. Macbeth. Macbeth.

Macbeth wakes up.

MCB. What?

LM. <u>That which hath made them drunk hath made me bold:</u> <u>What hath quenched them hath given me fire. The doors are open,</u> <u>and</u> <u>the surfeited grooms do mock their charge with snores.</u>

The bell rings once.

MCB. <u>I go and it is done: the bell invites me. Hear it not,</u> <u>Duncan'</u> <u>for</u> <u>it is a knell that summons thee to heaven or to hell.</u>

Macbeth exits to Duncan's chamber.
Lady Macbeth exits to get rid of the tray and cups.
The Porter, who has overheard everything, enters.

POR. How can the bell be a death knell? That don't sound right.

Lady Macbeth enters. The Porter hides.

End of Scene Two

ACT TWO, SCENE THREE

DUNCAN'S CHAMBER

> *Macbeth enters quietly.*
> *He approaches the sleeping king.*
> *An owl screams.*
> *Crickets cry.*
> *MCB trips and falls. Freezes.*
> *Nothing moves.*
> *After a few beats, he gets up and gets the daggers.*
> *He stabs Duncan several times.*
> *The MMM appears.*
> *The ambience changes to a nightmare.*
> *The castle shudders.*
> *Thunder roars.*
> *Lightning claps.*
> *And reverberating laughter fills every empty space.*
> *Macbeth is terror-stricken.*

MMM. <u>Sleep no more</u>!
 <u>Macbeth does murder sleep.</u>
 <u>Sleep no more</u>!
 <u>Glamis hath murder'd sleep:</u>
 <u>And therefore Cawdor</u>
 <u>Shall sleep no more.</u>

<u>Macbeth shall sleep no more</u>!

The MMM disappears.
The ambience becomes normal.
All is quiet.
Macbeth runs from the chamber, carrying the daggers.

BANQUET HALL

Lady Macbeth awaits Macbeth's return.
The Porter is still in his hiding place.
Macbeth enters. He is shaken.

MCB. <u>I have done the deed.</u>
LM. <u>Why did you bring these daggers from the place? They must lie there: go carry them and smear the sleepy grooms with blood.</u>
MCB. <u>I'll go no more. I am afraid to think what I have done;</u> <u>Look on't again I dare not.</u>
LM. <u>Infirm of purpose! Give me the daggers.</u>

He gives her the daggers. She exits.
Macbeth exits.
The Porter peeks out from his hiding place.

POR. Something ain't right here. I better do me a little investigatin'.

He exits.

DUNCAN'S CHAMBER

Lady Macbeth enters with the daggers.
She dips them and her hands in Duncan's wounds. Then she goes into the corridor where the chamberlains lie.
The Porter arrives, through a secret passageway, just in time to see her smear the attendants with blood and place the bloody daggers next to them. She exits.

POR. I better go get some help. But who am I going to tell? If I tell the rulers of this castle, they will kill me for knowing too much. If I accuse them to the other nobles, I will lose my head for the trouble. And if I tell the other servants, one of them will go blab it, and we'll all die. I gotta tell somebody. But who? Who?

He exits.

<p align="center">End of Scene Three</p>

ACT TWO, SCENE FOUR

BANQUET HALL

Macbeth enters guzzling from a jug of wine.
Lady Macbeth enters, approaches MCB.

LM. <u>My hands are of your color.</u>

MCB kisses her hands.
Takes her in his arms.

MCB. (*Sings*) Oh, so deeply is my love in you. I'm on fire with my love for you. A funeral pyre is my love for you
This is the beginning of our end. I'm going to burn out with you. And cool we'll rest in the ashes of our passion.
Though a heat shall remain. Burning low and simmering. Waiting for that spark of love to make the flames jump again.
You inspire my love to burn anew. My desire is to make love with you. I never tire of my love for you.

The song ends.
There is knocking at the gate.

LM. <u>Retire we to our chamber.</u>

Knocking.

LM. <u>Hark! Get on your nightgown.</u>

 They exit.
 The Porter enters with the Kitchen Maid.

POR. Meet me in my room.
KM. Your room?
POR. I've got something to tell you. It's important.
KM. You got to be kiddin'.
POR. Honey, this is no time to argue. Your boyfriend is in trouble.
KM. Junebug?
POR. Who?
KM (*sighing*). Oh, Junebug.
POR. Who is Junebug? Never mind.

 Knocking.

POR. They call at the gate. Gotta answer it. Go to my room.
KM. Why can't you tell me now?

 Knocking.

POR. Not enough time. Now go.
KM. Okay. But if you try something—
POR. (*Interrupting*) I won't. I promise. Go.

 She exits.

POR. (*To self*) Junebug. How awful.

Knocking.

POR. <u>Here's a knocking, indeed</u>!

He exits.

End of Scene Four

ACT TWO, SCENE FIVE

CORRIDOR

The Old Chamberlain wakes up.

OCH. Okay, kid. Hit the deck. Duty calls. Let's go. Reveille!

He sees the blood.

OCH. Hmm. I must've had a nosebleed.

He sees the bloody dagger.

Oh . . .

He stifles a scream.
Goes over and looks at the Young Chamberlain.
He sees that he is covered with blood and his bloody dagger.

OCH. Oh, no . . . God forgive me. I've killed my son. No, it can't be true. This is a dawn delusion. Dancing night daring daylight. (*To YCH*) Please don't be dead. There's so much I wanted to tell you. About me. About your mother. She didn't die after you were born. She left me for another man. Left you with me and split. You're full of her restlessness. But I wouldn't kill you for

that. I didn't kill her. I loved her. I love you. Oh, God, forgive me. Oh, God . . .

The Young Chamberlain wakes up.

YCH. Why should God forgive you, Dad?
OCH. Dammit, boy! Don't play with me like that! You ain't the king.
YCH. What are you talking about?

He sees the blood.
Screams.

OCH. Shhhh. Calm down. Lie still.
YCH. But your hands and face are covered with blood.
OCH. So are yours, Don't move.
YCH. Why?
OCH. Quit acting like your mother.
YCH. What's that supposed to mean?
OCH. Nothin'. I'm sorry. I didn't mean anything by that. Your mother was a beautiful creature. It was me. I was too wrong, too slow, and too dull too often.
YCH. I'm scared, Dad. I'll be good. Please don't hurt me.
OCH. There ain't nothin' to fear. I'm not gonna hurt you.
YCH. But the blood . . . and you asking God for forgiveness sounded like you were gettin' ready to do me.

OCH laughs.

OCH. Yeah. You got your mother's imagination, all right. Don't worry, son. The king is probably playing one of his famous practical jokes on us. Let's just go along with it.

End of Scene Five

ACT TWO, SCENE SIX

BANQUET HALL

The Porter enters, followed by Macduff and Lennox.

LEN. What took you so long, old man? Can't party like you used to, eh?
POR. Nay, milord.
MACD. <u>Was it so late, friend, ere you went to bed that you lie so late?</u>
POR. Aye, milord.
MACD. <u>Is thy master stirring</u>?
POR. Aye, milord. And milady too.
MACD. Scandalous were they? Heh, heh. That's the way it is after winning a war. Victory excites all the nerve endings and makes you want to make love like a hare in heat.

Macbeth enters in his wife's nightgown, wearing a stocking cap.

POR. See where milady comes.

He sees that he has made a mistake.

POR. Oh . . . I mean . . . See where milord comes. (*To MCB*) I'm sorry, milord. My eyes are old and uncertain.
MCB. Get out of here.

The Porter exits in a hurry.

LEN. Good morrow, noble sir.
MCB. Good morrow, both.
MACD. Is the king stirring, worthy thane?
MCB. Not yet.
MACD. He did command me to call timely on him: I have almost slipp'd the hour.
MCB. I'll bring you to him.

They exit.

CORRIDOR

The Old Chamberlain and the Young Chamberlain.

YCH. Dad? Am I a lot like my mom?
OCH. More than I care to remember.

Approaching footsteps.

OCH. Shhhh. Close your eyes. Pretend to sleep.

YCH and OCH play sleep.
MACD enters Duncan's chamber.

MACD. Good morrow, good Duncan. T'is I, Macduff. Calling timely. Awake, good sir.

Approaches bed.

MACD. Come on, you ol' sly fox. I know you aren't sleeping.

He sees the blood, etc.

MACD. Aha! What is this? Another one of your practical jokes, dude?
You shouldn't play with death, milord.
Life is the joke. Death is the punch line. (*Sings.*)
Life is the joke. Death is the punch line.
And us? We're the fall guys living as we're told.
From womb to tomb, we're the butt of someone's fun.
The laughs never stop even when we're old.
Hahahaha. Laughs the merry prankster.
Hohohoho. I was funning all along.
Life is the joke. Death is the punch line.
And us? We're the dummies who don't know right from wrong.

End of song.
No response from Duncan.

MACD. (*Speaks.*) Oh . . . you're gonna make me work hard for this one, eh? That's because I'm ready for you this morning. But okay. I'll play your little game. I'll act scared so you can have the last laugh.

He backs off. Reapproaches Duncan's corpse.
He reacts to what he sees with mock horror.

MACD. Oh, no! My liege is dead. Oh, the blood! Oh. Sob. Sob. (*Stops acting.*) Come on, man. Git up. Time to go. I played along. Come, milord. Time's awastin'.

> *Macduff shakes Duncan's corpse.*
> *Sees he is dead.*
> *This time his reaction is for real.*

MACD. Oh. No . . . no . . .

> *He stumbles out of the chamber screaming.*

MACD. <u>O horror! horror! horror!</u>

> *The Old Chamberlain wakes up. He goes into Duncan's chamber and sees that the king is dead. Reacts.*

OCH. (*Projecting to YCH*) It ain't no joke. The king is dead.

> *He returns to the corridor.*

YCH. (*To OCH*) He was a bad dude.
OCH. That just goes to show you.
YCH. I thought he was a light sleeper.
OCH. So did he.

> *Approaching footsteps.*

OCH. Shhh. Here comes somebody. Play dead.

> *OCH and YCH pretend to sleep. The Porter enters with the Kitchen Maid through the secret passageway. They shake the chamberlains.*

POR. (*To OCH*) Wake up, you old fossil.

OCH. Ain't nobody sleeping. And what do you want?

POR. No time to explain. You've got to get out of here.

YCH. Why?

KM. The king is dead.

OCH. We know that already.

POR. But do you know the murderers plan to pin the killing on you?

YCH. Who?

POR. Never mind who.

OCH. Oh no. We've been set up.

POR. Oh yes. And if you don't leave now, you won't live to tell about it.

OCH. We can't run. If we run, they will say that proves our guilt.

POR. If you stay, you lose too.

OCH. I'll stay. But can you save my son?

YCH. Dad. I don't want to leave you.

OCH. Don't be a damned fool. Go. I'll be okay.

KM. But if he goes and there's only one of you here, then they'll know that one got away.

POR. She's right. (*To YCH*) Too bad, kid. You almost made it.

KM. Why don't you take his place?

POR. That does not appeal to me. I ain't no damned hero. Everybody has got to die for himself.

YCH. I don't want to desert my dad anyway.

OCH. If only your mother had felt like you.

He cries.
YCH moves to console him.

YCH. Don't cry, Dad.

The MMM appears and gestures. Everyone freezes except the Porter.

POR. What do I do?

MMM. The choice is yours.

POR. What about our deal?

MMM. Our deal was that if you help her get him, you get her.

POR. But if I help her get him, I won't get her.

MMM. How much of her can you get before you die?

POR. Meaning what?

MMM. Meaning her action will stop your heart.

POR. At least I'll die smiling.

MMM. Tell you what we'll do. You help her get him, and we'll see to it that you spend forever with Dolores.

POR. Let me think on it.

MMM. You study long, you study wrong.

The Porter thinks.

MMM. Hurry up and decide. We can't hold up this play much longer.

POR. How much time do I have?

MMM. None.

POR. That sure is a cold shot.

MMM. Make up your mind.

POR. Okay. I'll take his place. But let me handle it my way.

MMM. Deal.

The MMM gestures and disappears. The action continues.

POR. (*To YCH*) Take the girl and go get help. I'll stay in your place. Let's change shirts. YCH. Help? Where?

POR. The rebel stronghold in the mountains.

KM. We'll find it.
YCH. I can't let you do this.

The Porter takes off his shirt.

POR. You ain't letting me do a thing. I'm doing this for Dolores. Give me your shirt.
YCH. But—
OCH. (*Interrupting*) Boy, if you don't do like he says, I'll kill you myself.
KM. Give him your shirt.

The Young Chamberlain takes off his shirt, exchanges with the Porter.

KM. (*To POR*) Thank you.

She kisses him on the lips. He swoons.

POR. Whew! (*To YCH*) Boy, you got your work cut out for you.
YCH. (*To POR*) Thanks. (*To OCH*) I love you, Pops.
OCH. I love you too. Now get out of here.
YCH. Wait a minute! Won't they see that you are not me?
POR. Don't worry about that. We all look alike to them.
YCH. (*To OCH and POR*) You'll never be forgotten.
OCH. Dammit! Stop the lip flappin' and git!

YCH and KM exit through the secret passageway.

CH. Why did you do that?
POR. Do what?

OCH. Take my son's place?

POR. Oh, it doesn't matter.

OCH. No! Why did you do it?

POR. He's so young and happy. He must learn to persist despite shattered dreams. He must live to cry life's bitterest tears. He must live to grow old and bitter and misunderstood like you and me. He must live to learn what it is to love and lose. Why should he die now and miss all this misery?

MCB. (*Offstage*) Stay here. I'll see for myself first. You know it could be another one of our majesty's witty tricks.

OCH. Shh. Let's play this to the hilt. Give the kids more time.

POR. I'm with you, but couldn't you use a better image?

> *They lie down.*
> *The Porter covers his head and face.*
> *Macbeth enters.*
> *He looks the situation over, sees that all is in order.*

MCB (*calling*). Lennox!

> *Lennox enters.*

MCB. Look, Lennox. Blood.

LEN. There's a bloody lake in 'ere.

> *Lennox approaches Duncan's corpse. Reacts.*
> *Macbeth watches him.*

LEN. It's true. It's true. Our Lord Duncan has been slain.

Macbeth goes into his "act."

MCB (*wailing*). Ohhhh!

> *He watches Lennox to see what kind of effect his unbridled grief has on him. Then he indicates the daggers.*

MCB. Look, Lennox. Bloody daggers!

> *He picks one up.*
> *Lennox takes hold of the other.*

LEN. Yup. Here they are. Plain as day.
MCB. Do you know to whom they belong?
LEN. Nope. Maybe we should wake these bloody attendants.
MCB. What? Are they sleeping at this hour? Hasn't it been daylight for some time now, noble Lennox?
LEN. Yep.
MCB. Then why are they sleeping still?
LEN. I don't know. Wait a minute! I smell alcohol. These guys are probably sleeping it off.
MCB. I doubt it. Sleep's doors are forever closed to treacherors. Treasonous traitors.
LEN. Who are you talking about?

> *Macbeth points to the floor.*
> *Lennox looks and gasps.*

LEN. Look! Two trails of blood. One comes from each guy.

They lead to where the king lies.
He follows the trails of blood.

MCB. What sayest thou, noble Lennox?

Lennox weighs the evidence. Macbeth grows impatient.

MCB. Well?
LEN. Well . . . I say the evidence and the circumstances which I see with my own orbs indict this drunken duo of regicide. They must die.

The OCH and the Porter, with head and face covered, protest.

OCH/POR. We didn't do it! We are innocent!
MCB. Silence!

He and Lennox menace the innocents with the bloody daggers. They quiet down.

MCB. (*To Lennox*) I told you the devils weren't sleeping. Liars! Murderous cowards!

Macbeth goes into his "act" heavily.

MCB. (*To the servants*) Why did you stop with Duncan? Why not kill me too? I am of his blood. Dare you defile my house with this outrage? (*To Lennox*) Lennox, guide my free hand to that dagger you hold.

Macbeth reaches for the dagger.
Lennox holds it out point first.

LEN. I am in full accord with your actions. The punishment should fit the crime and be just as swift.

Macbeth pricks his hand on the dagger point.

MCB. Ow! Dammit, Lennox! Watch what you're doing!
LEN. A thousand pardons, Lord Macbeth.

He turns the dagger around and hands it to Macbeth, handle first.

OCH. As God is our witness.
MCB. Invoke not the name of God. You would do better to call upon the devil to accompany your black souls to hell. Die!

Macbeth kills them.
He and Lennox exit.
The MMM appears and gestures at the corpses.

MMM. Arise.

They arise as ghouls.

DUN. (*To OCH*) You idiot! I'd still be alive if you had been on your job, sucker.
MMM. Oh no! This is our turf. You are dead now. We rule here, and I don't allow no lesser majesties. In this realm, you are no more than any of the other spirits. Understood?

No Answer from Duncan.
MMM gestures. Duncan reacts as if receiving an electric shock.

MMM. Understood?
DUN. Understood.

MMM. You want revenge? Avenge yourselves on Lord and Lady Macbeth.
DUN. I'd love it.
MMM. You'll get your chance after the coronation. Right now, get ready for the funeral.
DUN Funeral? I haven't been dead that long.
MMM. I know, but the sooner you're buried, the sooner they get crowned.

Funeral music and wailers are heard from offstage.
MMM gestures. Duncan lies down like a corpse.
OCH and POR follow MMM off the stage.

DUNCAN'S FUNERAL

Duncan's corpse lies in state. The entire cast, minus the Old Chamberlain, Young Chamberlain, Porter, and Kitchen Maid, pays their last respects. First, Macbeth and Lady Macbeth, who moan and wail and carry on. And in between, Macbeth tries on the crown. They rob Duncan of his jewelry, including the gold in his mouth. Next comes Banquo, who after he salutes his dead leader, sings while the others pass by.

BAN (*sings*). While this death makes me sad, the curse sequences Macbeth to king.

Only a matter of time before my sons rule everything. Those ugly fates make it so. Duncan has been dispatched. In time, Macbeth will go. But for now . . . hail, Macbeth. Now art thou king. Hail, Macbeth . . .

He exits singing.
End of the funeral.
After Banquo leaves the stage, MMM gestures and Duncan rises.

MMM. The coronation begins in a few minutes. Now you can get your revenge.

DUN. Damn, they're moving fast. I didn't think my cousin was so cold. MMM. Family trait. They have what they have always wanted.

DUN. Now that they do, I want to make sure they stay awake and enjoy it.

MMM. Deal. Your revenge shall be to keep them awake forever.

DUN. With pleasure. I'll turn them into insomniacs.

DUN and MMM exit.

END OF ACT TWO

EPILOGUE

BANQUET HALL

Knocking is heard offstage.

MCB (*offstage*). Get the gate.

Macbeth enters half dressed in Duncan's royal robes.

MCB. Dammit! Where in the hell is that porter? (*Calls.*) Gatekeeper!

No response. The knocking persists.

MCB. Knock your knees, dammit! Geezer is probably so old he doesn't hear the knocking. I'll have to get rid of him.

Knocking gets louder.
MCB goes to open it.

MCB. Hold your water! Here I come.

He exits in the direction of the knocking.
LM enters dressed in exquisite royal finery and is carrying Duncan's royal robe.
MCB reenters. Lennox follows him in.

LEN. Royal majesties.

MCB. Not quite yet, good Lennox.

LEN. You already are. The coronation is just

MCB (*interrupting*). A serious rite which we do not take lightly.

LEN. Forgive me, my liege.

MCB. Forget it. Is all ready?

LEN. Yes, sir. The rest of the royal escort awaits beyond the gates.

MCB. Let's get on with it.

LEN. Before we do, may I speak with you, milord?

MCB. You may speak freely in milady's presence. We have no secrets.

LEN. I just want you to know that the sendoff you gave your cousin was fantabulous plus. He didn't even look dead. Just looked like he was dreaming up some gag.

MCB. If only it were so.

LEN. I'm gonna miss his tricks. And just when everything seemed to be going right for him. I wrote a poem to commemorate the occasion. I'll recite it for you.

MCB (*pained*). No, no. Please . . .

> *Lennox ignores Macbeth's pain and recites.*

LEN. There he lay like a toy, his silver skin, the vessel for his golden blood—

LM (*interrupting*). Really, Lennox! Must you persist? It was a funeral! Okay? It's over. Let's on with the coronation.

MCB. Yes, lyrical Lennox. We must carry on despite our sorrows.

> *Lennox steps aside.*
> *Macbeth and Lady Macbeth exit.*
> *Lennox follows them.*

THE CORONATION

The procession appears led by the servants, then the nobles, and finally Lord and Lady Macbeth. As they march, they sing.

ALL. Hail, Macbeth, king of everything.
It's happened at last. You are your dream.
Lord of lords. El supremo supreme.
Hail, Lady Macbeth. Superduper queen.
Hail, Macbeth. Now art thou king.
Hail, Macbeth. Lord of everything.
Hail, Lady Macbeth. Superduper queen.
You got it all. You got the king.

Silence.
Lord and Lady Macbeth are crowned.
The entire cast minus Macduff and the dead pay homage.
The pregnant girl presents her baby to the king and queen. After everyone leaves the stage, MCB and LM celebrate.

MCB (*sings*). We hid well our intentions
No one ever knew
We really killed our emotions
Our deceit never shew
We learned to grin and bear it
Put on a happy face.
Kept a sparkle in our eyes
And now we own the place.
The world is ours, baby
The world is ours, baby
The world is ours.

 Whatever it took, we did, baby
 The world is ours.
 We had to be extra careful
 For fear the walls might hear
 We had to watch how we acted
 Now our turn is here.
 I'm so tired of constantly thinking
 Feels so good to take off this mask
 Lose the bounce in my step
 We have completed our task.
 Now it's all over
 The world is ours
 Whatever was fair, we did it (actually foul)
 The world is ours
 I killed for you and glory
 And made this world ours
 I love you. I love you.
 The world is ours.

LM (*sings*). We did keep a low profile
 We went along with the play
 We overcame every obstacle
 That got in our way
 We always were natural
 Never taken by surprise
 Kept a tight rein on our feelings
 We were never caught in our lies

MCB (*sings*). Now it's all over
 The world is ours
 Whatever is fair we did it
 The world is ours.

As Macbeth and Lady Macbeth sing and party, the ghost of Duncan appears and haunts them.

DUN. Bingo, baby.

MCB. Dunk, please I can explain.

DUN. Shut up, sucker.

MCB and LM flee the stage with Duncan in hot pursuit. MMM appears.

MM. (To audience) Hey, everybody, you can have your dream. The MagicMindMonster is on the scene. We're the masters in creating the impossible. We'll grant you power, strength, and fame. We'll make sure that nothing or no one will stop you. Fulfilling your dream is our aim. <u>Fair is foul and foul is fair</u>: Stir, stir, stir.

As the MMM sings the *Stir, stir, stir,* The rest of the cast drifts in and join the Finale.

They all sing: "Hey, everybody! The MagicMindMonster is on the scene. Life is just an illusion, you can have your dream We're the masters in creating the impossible We can give you power, strength and fame We'll make sure that nothing or no one will stop you Fulfilling your dream is our aim. Dark shadowed paths will move out of the way Emotions and feelings are all cast away Destroy things of conflict 'cause you are priority

END OF THE EPILOGUE

END OF THE PLAY

buy the bi and bye

Felton Perry

Cast of Characters

for

buy the bi and bye

A1

A2

A3

A4

A5

WD

This play takes place in an off-mainstream theater in May 1976.

Cast of Characters

for
Killin' Flo'
(The play within *buy the bi and bye*)

Mary Ruth Jackson, also known as Mother Jackson
Beauregard Sylvester Jackson
Chastity Blanche Jackson
Josoyam Namgweele Jackson[2]
Cloreatha Lee Vester Jackson
Cleophus Lee Vester Jackson

[2] This character has no lines and can be represented by a doll.

Lights up

in order to differentiate one play from the other (since they both occur simultaneously), the dialogue and directions for Killin' Flo' *will be capitalized. The dialogue and directions for* Buy the Bi and Bye *will be in lowercase letters.*

four people are within the theater: WD, A1, A2, and A3. they are chatting with one another, or, as in the case with A3, they are reading the script. WD is relating to his watch and to the door, which is the entrance to the theater.

WD. she isn't coming. i just know it. yes, she is. no, she isn't. look, she said she'd come, right? yeah, but . . . so knock it off. she'll be here. i'm scared. if she doesn't show up, this will all be for nothing. you're nervous. i am not. yes, you are. you always scratch when you're nervous. just keep your cool. she'll be here. okay, okay.

WD exits.

A1. who was he talking to?
A2. his delirious tremors.

WD enters.

WD. damn it, why can't people get places on time?

A2. how is brother sarge?

A1. who?

A2. your husband.

A1. bored.

A2. bored? ain't he stationed over there where the female to male ratio is six to one?

A1. yep.

A2. what's he doing bored?

A1. he misses the war.

A4 enters.

WD. well, here's my main lady. how are you, baby?

A4. fine. how are you?

WD. need you ask?

A4. no, not really. where's the script?

WD. here. i wrote it just for you.

A4. have you started yet?

WD. naw, still missing one actor. thank you for coming. hey, everybody. this is a . . . er . . . uh . . .

A4. friend.

WD. yeah. she's reading the part of cloreatha lee.

A1. oh, yeah. hi. long time no see.

A4. hi. what part are you reading?

A1. may ruth.

A2. mama may-may.

A1. and this fool is reading cleophus lee vester.

A2. sister, you are so fine. you can open my nose anytime.

A1. you sure are jive.

A4. who's that?

A1. she's reading the white girl's part in this play.

WD. we're going to have to get started with or without that other actor . . . dammit. why can't people be on time?

A4. who is the other actor?

A2. blippy.

A4. bippy?

A2. blippy . . . the black hippy . . . always on a trippy. the conscientious objector the government put in prison for refusing the draft.

A4. i don't know him.

A2. you haven't missed a thing.

A4. what part is he reading?

A1. beauregard sylvester.

WD. cleophus, you read the other actor's part.

A2. aw, shit, man.

WD. just until he shows up.

A2. can't we wait a few more minutes? i don't feel like reading two roles.

WD. okay. we'll wait a couple more minutes. meanwhile, would you mind putting a couple of chairs and a small table on the stage?

A2. which side? right or left?

WD. right. no! left.

A2. up or down?

WD. down. up. down. up. down! down! okay. down. we're going to check outside to see if the actor is coming.

he exits. A2 gets a small table and two chairs and sets them on the stage. A1 helps him while A4 speaks to A3.

A4. hi.

A3. hi.

A4. have you been with this group long?

A3. no. this is my first time.

A4. how did you find out about it? are you a friend of the writer?

A3. no. i just met him a few days ago where i work. i heard him say that he needed an actress to read a part. so i told him i was an actress, and he gave me the script.

A2. (*to A1*) what are you going to do for the fourth of july?

A1. i hadn't thought about it. it's over a month away. why?

A2. i was checking out the news, and everybody is going all out to celebrate this year. president ford even invited the queen of england to be part of the official government celebration. like it's some big deal.

A1. it is a big deal. we've been free for two hundred years.

A2. we ain't been free ever. *they* been free.

A1. this is my country. my country is free. i'm free.

A2. we won't be free until we have our own revolution. just like *they* did.

A1. that sounds like some leftover sixties talk. this is nineteen seventy-six. you better catch up.

A2. nineteen seventy-six or not, the reality of the sixties still holds true.

A1. so you're not going to celebrate july fourth?

A2. i didn't say all that. i just wish it meant more to me than an extra day off from work.

A1. that's reason enough to celebrate.

A2. yeah, maybe so.

A1 laughs. WD reenters.

WD. that actor isn't coming. we can't wait any longer. you'll just have to read his part.

A2. yeah. okay.

WD. okay. let's begin.

WD opens his script to this page and reads aloud.

WD. LIGHTS UP. ACT ONE—KILLIN' FLO. THE PLACE IS THE GHETTO IN THE LATE NINETEEN SIXTIES. MARY RUTH JACKSON, ALSO KNOWN AS MOTHER JACKSON, A BLACK WOMAN IN HER LATE FORTIES OR EARLY FIFTIES, IS SINGING A HYMN WHILE VACUUMING THE WORN-OUT RUG IN HER SHABBY TWO-AND-A-HALF- ROOM APARTMENT, WHICH SHE SHARES WITH HER DAUGHTER, CLOREATHA LEE JACKSON. IN SPITE OF ITS DREARINESS, THE APARTMENT HAS A CLEAN FEEL TO IT. THERE IS A SOFA UPSTAGE RIGHT. IN FRONT OF IT SITS A CHEAP COCKTAIL TABLE. AT EACH END OF THE SOFA, THERE ARE END TABLES UPON WHICH SIT CHEAP TABLE LAMPS. ALONG THE RIGHT PORTION OF THE UPSTAGE WALL ARE TWO FAIRLY LARGE WINDOWS, WHICH OVERLOOK THE ALLEY AND MOUNDS OF GARBAGE. IN ONE CORNER OF THE RIGHT PORTION OF THE STAGE WALL ARE PICTURES OF MARTIN, ROBERT, AND JOHN UNDER A PICTURE OF CHRIST'S BIRTH SCENE. A PAPER WREATH ENCIRCLES THE PICTURES. THE WORDS "THEY DIED TO SET US FREE" ARE WRITTEN ON IT. THE DOOR TO CLOREATHA'S BEDROOM IS LOCATED ALONG THE UPPER PORTION OF THE RIGHT WALL. STAGE LEFT IS THE KITCHEN AREA. THERE IS A TABLE AND THREE CHAIRS SITTING LEFT CENTER STAGE. CABINETS LINE THE UPSTAGE LEFT PORTION OF THE REAR WALL. UNDERNEATH IS THE SINK AND

STOVE. ALONG THE UPPER PORTION OF THE LEFT WALL IS A REFRIGERATOR. THERE IS A DOORWAY LOCATED A FEW FEET DOWN THE REFRIGERATOR, WHICH LEADS TO THE BATHROOM AND MAMA'S BEDROOM. IT IS EARLY AFTERNOON.

A1. what hymn should i sing?

WD. one of those finger-popping, foot-stomping, sad songs.

A1. i don't know any of those kind.

WD. well, all i want really is a feeling . . . joyous misery.

A1. i'll fake something.

WD. let's start over. IT IS EARLY AFTERNOON.

A1. oh god. i'm so glad. i'm so glad. i got it bad. yes, i do . . . oh, i'm so glad. i'm so glad i got it bad. yes, i do. if i had it good, i'd be sad. but thank you, jesus . . . i got it bad. i'm so glad. i'm so glad. i got it bad.

WD. THERE IS A KNOCK AT THE DOWNSTAGE RIGHT DOOR. MOTHER JACKSON CONTINUES TO SING.

A1. who is that knocking at my door? if it's suffering and sorrow, i can handle more 'cause i'm so glad when i got it bad. yes, i'm is . . .

WD. A VOICE CALLS OUT.

A2. MAMA? MAMA?

A1. i'm so glad. i'm so glad . . . BEAUREGARD? BEAUREGARD? IS THAT YOU?

A2. YEAH. MAMA. IT'S US.

A1. US? BOY, WHAT ARE YOU TALKING ABOUT?

A2. OPEN THE DOOR, MAMA!

A1. WHO'S WITH YOU? SOME OF THEM DOPEHEADS YOU GREW UP WITH?

A2. NO, MAMA. MY WIFE.

A1. YOUR WIFE? YOU DONE GOT MARRIED, BOY?

A2. YES, MAMA! CAN WE COME IN?

A1. WAIT, I GOT TO PRAY FIRST.

WD. MAMA EXITS IN TO THE BATHROOM, SINGING HER HYMN MORE JOYOUS THAN BEFORE.

A1. trouble done knocked at my front door. come on in, trouble. this is the killin' flo'. i'm so glad. i'm so glad. i got it bad. amen.

WD. A BABY CRIES. THERE IS ANOTHER KNOCK ON THE DOOR.

A2. MAMA, WILL YOU PLEASE OPEN THE DOOR! THE BABY NEEDS TO BE CHANGED!

WD. THERE IS A LONG SILENCE . . .

A2. hi.

A3. hi.

A2. haven't seen you around here before.

WD. what was that you picked up last night? you were there. no, i wasn't. we probably caught something.

A2. welcome to our theater.

WD. stop scratching . . . PUNCTUATED BY AN OCCASIONAL BABY'S CRY. FINALLY MOTHER JACKSON REAPPEARS, CROSSES TO THE DOOR, AND OPENS IT.

A3. thanks.

A2. WHAT TOOK SO LONG?

A1. I HAD TO THANK THE LORD.

A2. MAMA, THIS IS MY WIFE, CHASTITY BLANCHE, AND OUR NEWBORN SON . . . uh, how do you pronounce this name?

WD. jo-soy-am nam-gweele.

A2. JOSOYAM NAMGWEELE?

A1. WHAT? WELL, Y'ALL COME ON IN.

WD. ENTER CHASTITY BLANCHE, A DIMINUTIVE WHITE GIRL OF NINETEEN OR SO. HER SKIN IS VERY WHITE. HER HAIR IS A FINE BLOND, ALMOST WHITE. HER

FEATURES ARE FINE AND FRAGILE. SHE IS HOLDING A BABY WRAPPED IN A BLANKET. BEHIND HER ENTERS BEAUREGARD SYLVESTER JACKSON, A BLACK MAN OF TWENTY-THREE YEARS OLD. HE IS CARRYING TWO SHOPPING BAGS.

A3. HELLO, MOTHER JACKSON. BO HAS TOLD ME SO MUCH ABOUT YOU.

A1. HE DIDN'T TELL ME ANYTHING ABOUT YOU. BEAUREGARD, WHEN DID YOU GIT MARRIED?

A2. MAMA, WE NEED A PLACE TO STAY JUST UNTIL I GET A JOB.

A1. YOU QUIT YOUR SCHOOL, DIDN'T YOU? I KNEW YOU WEREN'T GOING TO STICK IT OUT. NO BACKBONE. JUST LIKE YOUR DADDY.

WD. AN APPARITION APPEARS. MOTHER JACKSON'S HALLUCINATION OF HER HUSBAND, CLEOPHUS LEE VESTER JACKSON. this is the role we want you to read.

A2. DON'T BLAME THAT BOY ON ME, MAY-MAY. HE AIN'T MINE.

A1. YES, HE IS, CLEOPHUS LEE VESTER JACKSON. YES, HE IS.

A3. BO, WHAT'S WRONG.

WD. don't forget. you're reading beauregard too.

A2. shit.

A2 assumes his previous voice and character.

A2. MAMA'S JOKING. SHE'S OKAY. HERE, GIVE ME THE BABY. I'LL CHANGE HIM. SIT DOWN AND REST.

A1. BO VESTER, MAMA IS SO GLAD TO SEE YOU AND YOUR WIFE AND BABY. LORD, YOUR WIFE LOOKS A FRIGHT.

SO PALE AND FRAIL LOOKING. LOOKS LIKE SHE MIGHT BE SICK. HONEY, DO YOU FEEL ALL RIGHT?

A3. YES.

A1. NO, YOU DON'T. YOU DON'T HAVE TO LIE TO ME. I'M YOUR HUSBAND'S MOTHER. I LOVE YOU 'CAUSE YOU LOVE HIM. THIS IS YOUR HOME FOR AS LONG AS YOU NEED IT.

A3. THANK YOU, MOTHER JACKSON.

A1. COME ON AND GIT IN BED, HONEY. YOU LOOK LIKE YOU COULD USE SOME REST.

WD. CHASTITY BLANCHE AND MOTHER JACKSON EXIT TO HER ROOM. BEAUREGARD CHANGES THE BABY'S DIAPER. MOTHER JACKSON REENTERS AND GOES INTO THE KITCHEN AREA.

A1. THAT GIRL NEEDS SOME FOOD. BO, WHERE IS SHE FROM?

A2. WHERE EVERYBODY IS FROM. HER MAMA'S WOMB.

A1. DON'T GIT SMART WITH ME, BOY!

A2. MAMA, I AM NOT A BOY. I AM A MAN. TWENTY-THREE YEARS OLD!

A1. YOU'LL ALWAYS BE A BOY TO ME.

WD. CHASTITY CALLS FROM THE BEDROOM.

A3. BO, BRING THE BABY HERE. I'M GONNA FEED HIM. A1. WHAT'S THAT BABY'S NAME AGAIN?

A2. JOSOYAM NAMGWEELE. A1. HMPH!

WD. BEAUREGARD EXITS TO THE BEDROOM WITH THE BABY.

A1. OUR NAMES AIN'T GOOD ENOUGH FOR YOU, HUH? NO. YOU GOT TO BE DIFFERENT. THAT WAS ALWAYS YOUR DOWNFALL, BO VESTER. BEIN' DIFFERENT.

WD. ENTER CLOREATHA LEE JACKSON, A BLACK WOMAN IN HER LATE TWENTIES.

A4. BROTHERS AND SISTERS, IT IS TIME FOR US TO UNITE IN OUR COMMON STRUGGLE AGAINST THE COLONIAL, IMPERIALIST, BLOODTHIRSTY FEW WHO, THROUGH THEIR ARMIES AND AGENTS, CONTROL OUR DESTINIES!

A1. DON'T BRING THAT FOOLISHNESS IN HERE, CLO-LEE! A4. FREEDOM'S FIGHTERS ARE HAVING A MEETING IN ABOUT AN HOUR, AND I AM ONE OF THE FEATURED SPEAKERS.

A1. YOU OUGHT TO QUIT THAT FOOLISHNESS AND GIT A JOB.

A4. MAMA, I CANNOT WILLINGLY PARTICIPATE IN A SYSTEM WHICH I OPPOSE.

A1. YOU OUGHT TO KNOW THAT FREEDOM MESS DON'T MEAN NOTHIN' TO NOBODY.

A4. SOMEDAY IT WILL. MAMA, CAN I BORROW TEN DOLLARS?

A1. WHERE AM I GONNA GIT THAT KIND OF MONEY?

A4. AW, COME ON, MAMA. IT'S FOR THE CAUSE.

A1. CAUSE YOU'RE BROKE.

WD. MAMA REACHES INSIDE HER DRESS, PULLS OUT A FEW CRUMPLED BILLS, GIVES CLOREATHA TEN DOLLARS.

A1. HERE.

A4. THANKS.

A1. NOW WHEN DO I GET MY MONEY BACK?

A4. WHEN THE REVOLUTION COMES.

A1. MONEY WON'T BE NO GOOD THEN.

A4. NEXT WEEK.

WD. BEAUREGARD ENTERS.

A2. MAMA, CHASTITY IS . . .

WD. HE SEES HIS SISTER.

A2. CLO-CLO!

A4. BO-BO!

WD. THEY EMBRACE.

A4. WHEN DID YOU GET HERE?

A2. ABOUT A HALF HOUR AGO.

A4. DECIDED TO COME BACK, HUH?

A2. YEAH.

A4. I'M GLAD. I MISSED YOU.

A2. I MISSED YOU TOO.

A1. BO VESTER, WHAT DID YOU START TO SAY?

A2. CHASTITY SAYS SHE'S NOT HUNGRY.

A1. THAT PO' CHILE IS SO WEAK. SHE DON'T KNOW WHAT SHE'S TALKING ABOUT.

A4. WHO'S CHASTITY?

A2. MY WIFE.

A4. MY BABY BROTHER GOT A WIFE?

A2. YEAH, AND I'M TWENTY-THREE.

A4. WHEN?

A2. GOT A BABY TOO.

A4. REALLY? WHERE IS YOUR WIFE AND BABY?

A2. IN MAMA'S ROOM. COME ON.

WD. THEY EXIT INTO MOTHER JACKSON'S ROOM. CLOREATHA REAPPEARS ALMOST IMMEDIATELY AND GOES OUT. BEAUREGARD REAPPEARS.

A2. WHAT'S WRONG WITH CLOREATHA, MAMA?

WD. LIGHTS DOWN. ACT ONE, SCENE TWO. THE EARLY HOURS OF THE NEXT DAY. MOTHER JACKSON IS LYING ON THE SOFA. CLOREATHA IS SITTING ON THE COCKTAIL TABLE.

A1. he was talking to himself during that last scene.

A4. i know.

A1. you used to go with him, didn't you?

A4. we used to see each other a lot.

A1. what's wrong with him talking to himself like that?

A4. heavy boozer. i used to call him the plural one.

WD. what's happening?

A1. we thought we should whisper this scene because of the circumstances.

WD. use your voices. that's what we're having this reading for. we want to hear our language.

A1. WHY DON'T YOU LIKE THAT GIRL, CLO-LEE?

A4. YOU KNOW WHY, MAMA. SHE IS ONE OF THE ENEMY.

A1. THUS SAITH THE LORD. LOVE THINE ENEMY.

A4. I DON'T LOVE HER! I DON'T HAVE TO!

A1. YOU'RE SO FULL OF I! I THIS! I THAT! I AIN'T NO EXCUSE FOR FOLKS FIGHTING AND KILLIN' EACH OTHER. YOU BETTER GET RIGHT WITH GOD!

A4. MAMA, WHAT GOD ARE YOU TALKING ABOUT?

A1. THE CREATOR OF MAN.

A4. THE GOD OF THE ENEMY. NOT MY CREATOR.

A1. LORD HAVE MERCY, LORD. CLO-LEE, YOU ARE A RADICAL.

A4. THAT GOD AIN'T NEVER CARED NOTHING ABOUT YOU! A1. HUSH, CLOREATHA LEE! HUSH!

WD goes to the next page, 12-a. we added something.
A1 and A4 turn to 12-a and read.

A4. MAMA, HOW DO YOU KNOW THERE IS A GOD?

A1. THE BIBLE TELLS ME SO.

A4. THAT BOOK DON'T RELATE TO ME. IT'S LIKE EVERYTHING ELSE IN THIS SOCIETY. A WAY TO MAKE MONEY.

A1. THAT'S ENOUGH OUT OF YOU, CLO-LEE!

WD. now back to 12. we'll fix that.

A1 and A4 turn to page 12 and continue.

A4. GO ON . . . HIT ME, MAMA. HIT ME.

A1. WHERE DO YOU GET SUCH THOUGHTS FROM?

WD. BEAUREGARD ENTERS FROM MAMA'S BEDROOM.

A2. CLO-CLO, WILL YOU AND MAMA PLEASE LOWER YOUR VOICES TO THE WHISPER OF AN EARTHQUAKE? YOU'RE GONNA WAKE UP THE BABY.

A1. OH, THE BABY.

A4. TELL HIM, MAMA.

A2. TELL ME WHAT?

A1. BO VESTER, HOW LONG DO YOU AND YOUR WIFE INTEND TO LIVE HERE?

A4. SHE AIN'T NONE OF HIS WIFE, MAMA. THEY AIN'T MARRIED. SHE'S JUST SOME OLD SMART TRASH THAT CAUGHT A DUMB DARKY WITH A DONKEY DICK AND A BUZZARD'S BRAIN.

A2. CLO-LEE, YOU ARE ONE EVIL BLACK BITCH.

A4. DON'T CALL ME BLACK.

A2. YOU AIN'T BLACK?

A4. ARE YOU?

A2. YES.

A4. I KNOW YOU ARE.

A1. BO VESTER! CLOREATHA LEE! NIP IT! NOW, MR. MAN. YOU KNOW THERE IS ONE THING THAT I DO NOT ALLOW IN MY HOUSE, AND THAT IS A MAN CUSSING A WOMAN.

A2. SHE STARTED IT, MAMA.

A4. I DIDN'T CUSS.

A2. YOU SAID DONKEY DICK.

A1. I DONE TOLD YOU NOW, BOY!

A2. BOY? MAMA, I AM TWENTY-THREE YEARS OLD. I AIN'T NO BOY.

A1. YOU'LL ALWAYS BE A BOY TO ME! BO VESTER, ARE YOU AND THAT GIRL REALLY MARRIED?

A2. YES, MAMA.

A1. WHERE'S THE LICENSE?

A2. WE DIDN'T MARRY LIKE THAT.

A1. WAS THE UNION BLESSED BY GOD?

A2. NOBODY TOLD US.

A1. WERE YOU MARRIED BY A PREACHER?

A2. YES, MAMA. FATHER WIND BLEW THE CEREMONY, SISTER EARTH WAS THE CHURCH, BROTHER WATERS SANG THE PRAISES, AND MOTHER SUN WAS OUR WITNESS.

A4. HE'S MAKING FUN OF YOU, MAMA.

A2. DAMN, CLO. WHY ARE YOU SO EVIL?

A4I. AM NOT EVIL. JUST FINAL. I DO NOT LIKE YOUR WIFE. I HATE HER.

A2. CLOREATHA, YOU ARE SICK. I'M GOING TO BED.
WD. BEAUREGARD EXITS INTO THE BEDROOM.
A4. YOU ARE THE SICK ONE, BEAUREGARD SYLVESTER JACKSON.
YOU'RE THE ONE WHO IS SLEEPING WITH YOUR ENEMY. YOU'RE THE ONE WHO WANTS TO BECOME SOMETHING IN THIS SOCIETY WHOSE GOOD HEALTH DEPENDS ON KEEPING YOU SICK.
A1. CLO LEE, DON'T YOU BOTHER BO VESTER AND HIS WIFE. NOT IN MY HOUSE.
WD. CLOREATHA DOESN'T RESPOND. SHE EXITS OUT OF THE DOOR, WHICH LEADS TO THE OUTSIDE. MAMA SINGS AS SHE GETS ON HER KNEES TO PRAY. LIGHTS DOWN. ACT ONE, SCENE THREE. DREAM SEQUENCE—FLASHBACK.
A2. wish that actor would hurry up and get here. i'm tired of reading his and my part.
A1. you're doing just fine, son.
A2. later for you, mama. HEY, BITCH.
A1. CLEOPHUS LEE VESTER JACKSON, WHAT IS WRONG WITH YOU?
A2. GIVE IT UP. I WANT IT.
A1. DID YOU GO TO WORK TODAY?
A2. I'M INTO FEELING GOOD, AND YOU'RE TALKING ABOUT SLAVING. HELL, NO, I DIDN'T GO TO WORK TODAY. I'M GETTIN' READY TO GO TO WORK NOW!
A1. BE CAREFUL NOW, CLEOPHUS LEE.
A2. I'M GITTIN' IT . . . MAY RUTH.
A1. THINK YOU CAN HANDLE IT?
A2. THINK I CAN'T? I'M READY NOW.

A1. DON'T BE UNDRESSING IN FRONT OF ME!

A2. TAKE YOUR CLOTHES OFF, THANG. WE'RE GOIN' TO THE KILLIN' FLO'.

A1. NO, I DON'T GIT NAKED IN FRONT OF NO MAN.

A2. MAY MAY, I AM NOT JUST ANOTHER MAN. I AM YOUR HUSBAND.

A1. CLEOPHUS LEE VESTER, YOU'RE TALKIN' CRAZY! WHAT'S WRONG WITH YOU?

A2. HEY, MAMA, CALL ME LEE VESTER. DROP THE CLEOPHUS. LEE VESTO IS BETTO. LEE VESTER THE LOVER, SWEET TALKER, AND KID GLOVER. GIVE IT UP, MAY MAY. GIVE IT UP.

A1. CALL ME RUTH. WHITHER THOU GOEST.

A2. DAMN. WHERE DID THAT COME FROM?

A1. MY GRANDMOTHER NAMED ME RUTH AFTER RUTH IN THE BIBLE, WHO TOLD HER MAN, "WHITHER THOU GOEST."

A2. bet you can't say that line again with a straight face.

A1. get back in character, silly. you're holding things up.

WD. what's happening?

A2. this next line . . .

WD. what about it?

A2. i don't understand it in terms of the character.

WD. what's there to understand? the character is not always logical in a point-to-point straight line relationship. logic is present, but a logic which cannot even be understood by us . . . and we wrote it.

A1. i heard that.

A2. there's two of you, and y'all don't understand it?

WD. however, we are not both present at this moment. the director is here, the writer isn't. i am, so shut up. we'll talk to the writer about the line at the first possible moment.
A2. no hurry. i think i can deal with it. you all made it clear.
WD. good. where do you want to start from? you can speak to me now about that line. hang on.
A2. uh . . . GIVE IT UP, MAY-MAY. GIVE IT UP.
WD. okay, you got that, mama?
A1. yeah, i got it.
WD. okay, as soon as we return, you pick it up from there. we're going to call the late actor to find out what the holdup is.

WD exits stage right. A4 follows.

A1. you dirty dog.
A2. bow wow.
A1. you're not going to shake me.
A2. i want to hear you read that line again.
A1. that line ain't nothing.
A2. you should've seen yourself when you read it. face contorted, body got fidgety, and you started breathing in lumps.
A1. some changes need to be made in this script.
A2. like the whole thing. call me ruth.
A1. forgit you, nigger.

A3 enters singing.

A3. I'M GONNA SATISFY HIM IN EVERY WAY NO MATTER WHAT HIS NEEDS MAY BE. I'M GONNA MOVE AROUND HIM SO FAST, HE'S GONNA BE SURROUNDED BY ME.

A2. wrong cue, chastity.

A3. i heard my cue. didn't you say "FORGIT YOU, NIGGER?"

A1. yeah, but we weren't doing the play. we were being for real.

A3. oh.

A2. what do you think of this play?

A3. i like it. the story of a white girl married to a black boy living with his mother and sister in their ghetto apartment during the late sixties is explosive.

A2. yeah. boom . . . boom.

A3. what?

A2. boom-boom. the explosion. dig, the next time you hear the word "nigger," it will be your cue. we will be doing the play.

A3. thanks. i'm so involved back there trying to get a sense of the lines and my character that i block out everything except my cue.

A2. you don't have to work so hard.

A3. i have to try to make the character real for me.

A1. your character isn't real?

A3. no. she's just this naive little girl with a baby.

A2. ain't that enough?

A3. no. i need more. there's not enough here for me to really understand what's going on with her.

A1. like what?

A3. like how she met bo and where. why she loves him and who she was before they met.

A2. why is all that important?

A3. so that the audience can understand what i'm going through.

A2. maybe i can help you. let's go backstage and see if we can uncover your character's meaning.

A3. thanks, but no thanks.

A1 laughs.

A1. you're all right, girl. nothing like your character.

A3. i want this part. I came to this town to act.

A1. where are you from originally?

A3. upstate. my parents have a house near the state line.

A1. that's beautiful country up there.

A3. yeah, i guess so.

A1. do you ever go back.

A3. no. it's pretty and pleasant and all that, but there's no excitement.

A1. how did you get interested in acting?

A3. marilyn monroe. she's so good. i know all her movies by heart: *bus stop, asphalt jungle, some like it hot, the misfits* . . .

A1. i saw that one. with clark gable, right?

A3. yeah. she was so good in that. so vulnerable. she had so much to offer but never got the chance.

A1. she died so young.

A3. yeah . . . my parents are furious with me for wanting to be an actress, especially my mother. she doesn't think that acting is an honorable profession. she wants me to be an obstetrician like she is, devote my life to medicine. she believes women have to take care of each other because men don't know what being a woman means.

A1. she has a point.

A3. i don't agree or disagree. she's probably right, but i want to be an actress. if i get sick, i'll go to a woman doctor, but i don't want to be one.

WD and A4 enter.

WD. i don't hate your brother. he just never liked me.

A4. you didn't understand him.

WD. how can i not understand being called honkey boy all the time?

A4. he was hurting. don't you understand?

WD. explain it to me later. (*to chastity*) what's wrong, chastity?

A3. nothing. i'm going back to study my lines.

A3 exits.

WD. mama? lee vester? are you ready?

A1. yeah.

A2. stay ready.

A1. nigger, you ain't never gonna be ready.

A2. just deal with that line.

WD. oh yeah. that actor wasn't home. probably on his way. let's go.

A2. GIVE IT UP, MAY-MAY. GIVE IT UP.

A1. CALL ME RUTH. WHITHER THOU GOEST.

A2. DAMN! WHERE DID THAT COME FROM?

A1. MY GRANDMOTHER NAMED ME RUTH AFTER RUTH IN THE BIBLE, WHO TOLD HER MAN . . . fool, you are not going to shake me. . . WHITHER THOU GOEST.

A2. ADD A "T" TO RUTH, AND YOU GOT TRUTH. I AIN'T GOT NO TIME FOR THAT. I'M A CUTTIN', KILLIN' NIGGER. BEEN THAT WAY SINCE MY YOUTH.

A1. I LOVE YOU, LEE VESTER.

WD. (*to A4*) i love you.

A2. GOT NO TIME FOR LOVE UNLESS IT BE FOR SOME MONEY.

A1. AIN'T GONNA SAVE YOU FROM GOD'S JUDGMENT. YOU CAN'T BUY GOD.

A2. GOD IS MONEY.

A1. LEE VESTER, I DON'T WANT THE DEVIL'S THOUGHT IN THIS HOUSE.
A2. WHAT IN THE HELL DO YOU MEAN? THIS IS MY HOUSE. I'M THE MAN AROUND HERE. AND DON'T YOU FORGIT IT.
A1. NO, I WON'T FORGIT YOU, NIGGER.

A3 enters singing.

A3. I'M GONNA SATISFY—
WD. not yet, chastity. i want to read the directions.
A3. sorry.

A3 exits.

WD. LIGHTS OUT. END OF MAMA'S DREAM. FLASHBACK SEQUENCE. ACT ONE, SCENE FOUR. THREE WEEKS LATER. CHASTITY BLANCHE IS ROCKING THE BABY IN HER ARMS AND WALKING THE FLOOR.

A3 enters.

A3. I'M GONNA SATISFY HIM IN EVERY WAY NO MATTER WHAT HIS NEEDS MAY BE. I'M GONNA MOVE AROUND HIM SO FAST HE'S GONNA BE SURROUNDED BY ME. GONNA FEEL SO GOOD TO HIM IN THE DARK. I'LL BE THE ONLY LIGHT HE CAN SEE. I'M GONNA STAY ON THAT MAN'S MIND. HE'LL NEVER FORGET ME. EVERYWHERE HE LOOKS, THERE I'LL BE. IN HIS COFFEE, MILK, AND TEA. GONNA CREATE AN UNFORGETTABLE

FANTASY. REPLACE THIS HORRIBLE REALITY WITH LOVE AND ACTION THAT GIVE HIM SATISFACTION. THE ONLY ONE FOR HIM WILL BE ME. PRETTY LITTLE BABY, GO ON AND CRY WHILE I SING YOU A LULLABY. CLEAN YOUR BODY AND YOUR MIND WITH THE SWEET DREAM-MAKING MOTHER'S WINE.

WD. CLOREATHA ENTERS FROM THE OUTSIDE.

A3. HI, CLOREATHA.

A4. IS MY MOTHER HERE?

A3. I DON'T KNOW. I HAVEN'T SEEN HER. I JUST CAME OUT OF THE ROOM WITH THE BABY. JOSOYAM, SAY HELLO TO YOUR AUNTIE CLO.

A4. WHERE'S BRAINWASHED BEAUREGARD?

A3. YOU DON'T LIKE ME, DO YOU?

A4. NO.

A3. WHY?

A4. YOU DON'T MEAN HIM NO GOOD.

A3. I LOVE HIM.

A4. ELF SHIT.

A3. WHAT?

A4. ELF SHIT! YOUR LOVE FOR MY BROTHER IS AS REAL AS THE TURDS FROM A FIGMENT OF YOUR GRAY IMAGINATION. YOU DON'T LOVE HIM. YOU LOVE HIS MANHOOD. I KNOW THAT YOU BITCHES ARE REALLY SPIES FOR THIS OPPRESSIVE SYSTEM, ANOTHER WEAPON. LULL THE BROTHERS TO SLEEP. ENSLAVE THEM, BLIND THEIR EYES WITH THE GLOW OF WHITE SKIN. THEY GET LOST IN WHITENESS AND BECOME LIKE TRAVELERS LOST IN A SNOWSTORM. THE COLD WIND OF YOUR DEAD RELIGION BLOWS ON THEIR SOULS.

DEADENING AND FREEZING THEM INTO VALUES WHICH ARE DIRECTLY CONTRADICTORY TO THEIR EXISTENCE.
A3. HOW CAN YOU SAY THAT?
A4. YOU'RE A NARCOTIC. WHITE AND DEADLY. I HATE YOU!

there is a pause.

WD. whose next line is it?
A4. beauregard's.
WD. beauregard. dammit! it's your line.
A2. the actor playing beauregard didn't show up yet.
WD. yeah.
A2. so i'll continue reading his part. what page is that on?

a voice is heard offstage.

A5. i'm here!

enter A5.

WD. well, you arrived on cue. ENTER BEAUREGARD FROM THE BEDROOM.
A5. i'm ready. give it to me.
A4. I HATE YOU!
A5. HEY, WHAT'S GOIN' ON?
A3. YOUR SISTER ATTACKED ME!
A4. I HATE THIS BITCH!

A3. WHY? BECAUSE I'M WHITE? I CAN'T DO ANYTHING ABOUT THAT! YOU'RE BLACK! YOU CAN'T DO ANYTHING ABOUT THAT!

A4. DON'T CALL ME BLACK, BITCH! I LOOKED UP THE DEFINITION OF THAT WORD. IT IS THE MOST NEGATIVE WORD IN THE LANGUAGE. I AM NOT NEGATIVE. I AM POSITIVE. POSITIVELY GONNA KICK YOUR ASS!

A5. DON'T DO IT, CLO LEE! DON'T HIT MY WIFE!

WD. MOTHER JACKSON ENTERS. FROM THE BATHROOM.

A1. WHAT IS GOING ON HERE? YOU ALL ARE MAKING SO MUCH NOISE I HAD TO CUT MY PRAYERS SHORT. BEAUREGARD?

A5. YES, MAMA?

A1. WHAT'S HAPPENING?

A5. NOTHING, MAMA.

A1. DON'T LIE TO ME, BOY.

A5. MAMA, I AM TWENTY-THREE YEARS OLD. I'M NOT A BOY. I'M A MAN.

A1. YOU'RE STILL A BOY TO ME AS LONG AS YOU'RE IN MY HOUSE! THIS IS MY HOUSE! I'M THE ONLY ONE PAYS RENT HERE! AND THAT REMINDS ME. HAVE YOU BEEN LOOKING FOR A JOB?

A5. YES, MAMA.

A1. WELL?

A5. I DIDN'T FIND ONE YET.

A1. BEAUREGARD, HAVE YOU BEEN DRIKIN' AGAIN? UH-HUH. JUST LIKE YOUR NO-GOOD DADDY!

WD. ENTER MAMA'S HALLUCINATORY CLOEPHUS LEE IMAGE.

A2. DON'T PUT ME IN YOUR CONVERSATION, MAY MAY. THAT BOY AIN'T JUST LIKE ME IN NOTHIN'. HE MIGHT NOT EVEN BE MY SON. NOW THAT I THINK ABOUT IT.

A1. LEE VESTER?

A5. MAMA, WHAT'S WRONG?

A1. YOUR DRINKING IS WHAT IS WRONG!

A3. BO'S DRINKING IS NOT A PROBLEM, MOTHER JACKSON. THE PROBLEM IS HERE IN THIS FILTH.

A4. THIS IS THE ONLY PLACE HE CAN TRULY CALL HOME.

A3. THERE'S DIRT AND GARBAGE AND PEOPLE EVERYWHERE!

A4. NOW YOU KNOW WHY WE NEED OUR MEN FOR THE REVOLUTION.

A3. CLOREATHA, I WISH YOU COULD UNDERSTAND THAT I TRULY LOVE YOUR BROTHER. CLOREATHA, WHY WON'T YOU TALK TO ME? IF I WERE BLACK, WOULD YOU STILL HATE ME?

A1. CLOREATHA LEE VESTER, I DONE TOLD YOU ABOUT BOTHERING CHASTITY BLANCHE. I'M NOT GOIN' TO HAVE DISSENSION IN MY HOUSE!

A4. I'M MOVING! THIS HOUSE AIN'T BIG ENOUGH FOR ME AND THIS BIT—

A1. DON'T SAY IT! JUST GIT YOUR CLOTHES AND MOVE ON OUT!

A5. CLO-CLO, DON'T GO NOWHERE! MAMA AIN'T SERIOUS.

A1. YES, I AM. SERIOUS AS A HEART ATTACK COMPLICATED BY CANCER. A QUESTION WITHOUT AN ANSWER.

A4. YOU, BEAUREGARD SYLVESTER JACKSON, ARE A BRAINWASHED COUNTERREVOLUTIONARY NIGGER. YOU ARE TRULY BLACK IN EVERY SENSE OF THE WORD.

A NEGATIVE BEING LOOKING FOR MEANING IN THAT WHICH DESTROYS YOU.

WD. CLOREATHA EXITS IN A HUFF.

A4 huffs!

A1. CLOREATHA LEE, COME BACK HERE AND CLOSE THAT DOOR! CLOREATHA LEE! YOU HEAR ME! HUSSY! BEAUREGARD, CLOSE THAT DOOR.

WD. BEAUREGARD CLOSES THE DOOR.

A3. I'M SORRY ALL OF THIS IS HAPPENING, MOTHER JACKSON.

A1. DON'T FRET ABOUT IT, BABY. LOOK AT BEAUREGARD… LAYIN' ALL OVER THE SOFA, PASSED OUT FROM DRINKIN' THAT BAD ALCOHOL. STUFF CAN BLIND YOU. YOU'RE JUST LIKE YOUR FATHER.

WD. APPEAR THE CLEOPHUS LEE APPARITION.

A2 I. TOLD YOU TO DROP ME FROM YOUR CONVERSATION, WOMAN! HE DON'T DO NOTHIN' JUST LIKE ME. MAKE BABIES OR DRANK THE SPIRITS.

A1. LEE VESTER? LEE VESTER, I SEE YOU. LEE VESTER, YOU NO-COUNT—

A5. MAMA, YOU'RE TALKING TO ME, BO VESTER! MAMA!

WD. BEAUREGARD TURNS TO CHASTITY.

A5. TAKE THE BABY IN THE ROOM. MAMA IS HALLUCINATING. MAMA!

A3. WHAT ARE YOU GOING TO DO?

A5. TRY TO SNAP HER OUT OF IT.

A3. OH, BO, WE HAVE TO MOVE FROM THIS PLACE.

WD. SHE EXITS WITH THE BABY TO THE OTHER ROOM.

A1. LEE VESTER, WHO WAS THAT WOMAN JUST WENT IN THAT DOOR?

A5. MAMA, THIS IS BO VESTER. YOUR SON. BO VESTER.

A1. WHO WAS THAT WOMAN?

A5. THAT WAS NO WOMAN. THAT WAS MY WIFE.

A1. YOU AIN'T NO GOOD, NIGGER. I DON'T KNOW WHY WE EVER GOT MARRIED! I WOULD'VE BEEN BETTER OFF WITHOUT YOU!

A5. MAMA . . .

A1. GO AWAY FROM ME!

A5. MAMA!

A1. DON'T SAY NOTHIN' TO ME. GET AWAY!

A5. OKAY, MAMA. I'LL GET AWAY!

WD. BEAUREGARD EXITS TO JOIN CHASTITY BLANCHE. THE APPARITION OF CLEOPHUS LEE APPEARS. THE SCENE SLOWLY CHANGES INTO A TWILIGHT AREA. MAMA IS HALLUCINATING.

A1. LEE VESTER, PLEASE DON'T GO! DON'T TAKE THE BABY'S MILK MONEY.

A2. MAY, THE BABY DON'T NEED THAT MILK AS BAD AS I NEED MY MILK. IT MAKES ME STOP CRYING. LOSE SIGHT OF THIS REALITY AND BE ENJOYING THE HELL OUT OF MY MIND. WHERE BEAUTY EXPOSES, IT'S ESSENTIAL UGLINESS, WHICH IS A LOVELINESS THAT ONLY I CAN UNDERSTAND.

A1. LORD, THAT STUFF GOT YOU TALKING OUT OF YOUR MIND.

A2. YOU USED TO COULD UNDERSTAND ME, MAY.

A1. NOT SINCE YOU STARTED STICKING A NEEDLE IN YOUR ARM.

A2. YOU GOT SCARED, MAY. YOU CHANGED ON ME.

A1. YOU THE ONE DONE CHANGED, LEE VESTER, SINCE YOU BEEN HANGIN' AROUND THEM SOUTHSIDE NIGGERS.

A2. THEM NIGGERS ON THE SOUTHSIDE DON'T KNOW NO MORE THAN NIGGERS ANYWHERE IN THE WORLD KNOW. WHAT NIGGERS KNOW ABOUT CAN'T BE WRITTEN OR EVEN TALKED ABOUT 'CAUSE NIGGERS DON'T KNOW THEY KNOW.

A1. WHAT?

A2. I KNOW I BEEN WRONG A FEW TIMES, BABY, BUT LOVE ME, PLEASE . . . I LOVE YOU. YES, I DO. I NEED YOU. YES, I DO.

A1. IF YOU LOVE ME, THEN GIVE ME BACK THE BABY'S MILK MONEY.

A2. IF YOU LOVED ME, YOU WOULDN'T ASK FOR IT.

A1. THAT BABY IS SICK. DOCTOR SAID TO GIVE HIM LOTS OF MILK.

A2. YOU GOT A TITTY.

A1. I DON'T MAKE ENOUGH MILK TO SATISFY HIM.

A2. LET HIM DIE THEN. this is shit.

A1. OH, LORD. OH, LORD. MAY GOD HAVE MERCY ON YOUR SOUL.

A2. WHY SHOULD GOD HAVE ANY MERCY ON ME? GOD MADE ME IN HIS OWN IMAGE. I AM ONLY BEING WHAT I WAS CREATED TO BE!

A1. HUSH UP, SATAN!

WD. MAMA FALLS TO HER KNEES.

A2. ouch, shit!

A2. THAT'S RIGHT. GIT ON YOUR KNEES. PRAY TO YOUR GOD. I REMEMBER ONE WINTER WHEN I WAS A LITTLE BOY. THEY FOUND A WHOLE FAMILY FROZEN TO DEATH. MAMA, DADDY, AND FOUR CHILDREN. DIDN'T HAVE NO MONEY. NO FOOD. TRAPPED IN A BLIZZARD. *ON THEIR KNEES!*

WD. MAMA PRAYS. CLEOPHUS LEE CONTINUES TO REPEAT "ON THEIR KNEES."

A1. OH, GOD, DELIVER ME FROM THIS VALLEY OF VEXATIONS. I PLACE MY CHILDREN AND MYSELF IN YOUR HANDS, KNOWING THAT YOU WILL MAKE A WAY.

WD. AND THE LIGHTS SLOWLY FADE TO BLACK. END OF ACT ONE. do you want to take a break or go right into act two?

A1. let's take a break. my knees are sore. if i do this mama role, i'm wearing kneepads.

A3. let's not break for too long. i have to go to work.

A4. yeah, i got a date with my boyfriend tonight. he doesn't like to wait.

WD. well, la dee da . . . okay. take five. who wants coffee? the writer is buying! i am? of course, you are. get enough for everybody. okay, we'll be right back. then let's go into the second act.

A3. want some company?

WD. we can manage. stop scratching.

A3. where's the bathroom?

A2. i'll show you. come with me.

A4 intervenes.

A4. i'll show her. (*to A3*) this way.

they exit. A2 approaches A5.

A2. you weren't reading from the script this last scene.
A5. yes, i was.
A2. where was it?
A5. in my mind.
A2. you memorized the script?
A5. i read it a few times.
A2. i did too.
A5. what's that supposed to mean?
A2. let's give the almighty creator of this play what they really want to see.
A5. what are you talking about?
A1. the plural one.
A5. who is that?
A1. the writer/director. the actress reading cloreatha calls him that. they were lovers.
A2. oh, yeah? she's a white folk nigger, huh? i knew she wasn't ready with her little stuck-up ass. ain't that right, brother?
A5. i ain't in that.
A2. aw, nigger. you're high. look at you. eyes red and half closed. body all broke to one side.
A5. that don't mean i'm high offa something.
A2. you know you're lyin'. here i am, runnin' my best revolutionary rap down, and this nigger is noddin'.
A5. drugged by your words. tripping into nowhere behind nothin'!

A4 enters.

A4. hey, does anybody have change for a dollar? or ten cents? i need to make a phone call.
A5. maybe i have.

A5 moves to A4.

A1. how is your wife?
A2. you mean my ex-wife.
A1. ex? since when?
A2. we've been divorced over a year now.
A1. i am really surprised to hear that. she was white, wasn't she? thin child? wore an afro wig all the time? one arm shorter than the other?
A2. uh . . . yeah.
A1. nice smile though.

A2 goes to A5.

A2. so says saint smoke.
A5. it's all in the toke.
A2. won't you share a little smile with me?
A5. okay, man. you got me. here

A5. gives A2 a handful of nothing.

A2. what's this?
A5. the best smoke your mind can imagine.
A2. this is supposed to blow my mind, huh?
A5. well?

A4 enters and goes to A5.

A4. here. line was busy.
A2. is that girl reading chastity blanche in the bathroom?
A4. yeah, studying her lines.

A2. just as well she ain't here. she wouldn't be with us no way.
A4. what are you talking about?
A2. us. u-s, she ain't one of us.
A4. that's unfair.
A2. i feel like being unfair. this play needs burning.
A5. is this some more of your revolutionary rap? if it is, speak for yourself.
A1. it just needs a little rewriting.
A2. alone, my voice counts for very little. but united, all of us with one spokesman—
A1. person.
A2. person, we can demand that we be heard.
A1. changes can be made.
A2. or we can declare ourselves independent, if no changes are forthcoming. we must be allowed to put forth our own image free of god's consent.
A5. god? who in the hell are you talking about?
A2. the writer-director. the plural one. the creator of this elf dookey. the characters are degrading and demeaning . . . mentally deranged cretins cavorting around the stage, puking pus on one another. we must be heard!
A5. why are you down on the brother?
A2. he ain't no brother of mine.
A5. okay, brother. whatever you say.
A2. he's a damned liar. you don't know him like i do. you were still in prison. he did me wrong.
A5. what did he do?
A2. do you remember that tv pilot he wrote?
A1. oh, yeah. i did a small part in that.

A2. well, i was supposed to be one of the stars in it. he wrote a main character in it based on me. he promised me the part.
A1. did you work in that too?
A2. no. he changed the character to a woman, and some sorry ass comedienne ended up with the part.
A5. maybe he had to do that in order to sell it.
A2. that's bullshit! he just lied to me. never did mean to give me the part. he just used me. i could be a star by now. at my age, i should've been done made it.
A1. it never did go nowhere. i don't even remember seeing it on the air. it must not have been that great.
A2. that's 'cause i wasn't in it. lying dog.
A5. so i take it that you don't like him.
A2. i hate him and this piece of shit he calls a play.
A1. the thing i don't like is, every time you look around, somebody is saying, "nigger this, nigger that." we don't talk like that all the time.
A5. naw, just most of the time.
A2. aw, nigger, please! will you be serious for a minute?
A5. i am serious as a heart attack complicated by cancer, as a question without an answer, as a crippled dancer, life romancer . . . laugh enhancer, and the king's lancer.
A2. don't be quoting that shit to me.

enter A3 running.

A3. did we start yet?
A4. no.
A3. oh, i thought i heard my cue.
A4. he's not back with the coffee yet.
A3. shit, i hope he doesn't take too long. i gotta go to work.

A2. oh, yeah? where do you work?

A3. in an all-night restaurant.

A2. what's the name of it? maybe i'll drop by and have a bite sometimes.

A3. frickin' chicken.

A2. on gallo and gallina?

A2 pursues A3 to the door leading to the bathroom.

A5. whatever happened to the revolution?

A1. she must remind him of his ex-wife.

A2. what in the hell are y'all laughin' at?

A1. i'm gonna join that little girl in the bathroom and school her about chicken lovers. hahaha!

A1 exits to the bathroom.

A2. so you aren't going to listen to me, huh?

A5. you ain't my daddy.

A2. you're gonna ignore me and make the same mistakes i did!

A5. you set the example.

A2. i'll see you on stage, m'boy. if the plural one gets back before i return, tell him that we want to talk with them.

A4. i ain't in that.

A2. i wasn't talkin' to you, miss white folks. i was speaking to blippy. you ain't ready.

A2 exits.

A5. he's suffering from delusions of old age, trying to play catch up. now he's gonna do all the things he thinks he should've done before.

A4. you know, he ain't even worth the argument. if i argued with him, then i really would *not* be ready.

there are a few moments of silence.

A4. let me have that dime back. i'm gonna try that number again.

A5 gives A4 the dime. A4 exits. WD calls from offstage.

WD. the coffee is here—cream, sugar, everything. come on and get it now. we want to get on with this play.

WD enters.

WD. where is everybody?
A5. i haven't seen them. are we gonna fix the roof?
WD. yeah. tomorrow morning at ten.
A5. we better if we want to keep this place from flooding.
WD. yeah. how come you were late?
A5. had to report to my parole officer.
WD. i understand. you better get your coffee before it gets cold.

intermission
end of intermission

WD. listen. what? i don't hear anything. shh. listen. to what? the silence.

WD listens. A4 enters.

WD. so? isn't it beautiful? yeah. stop scratching.

A4. who are you talking to?

WD. do you care?

A4. i wouldn't ask if i didn't.

WD. i'm sorry.

A4. i used to think you talking to yourself was just a put-on, but i see it's real.

WD. i've missed you a lot.

A4. what has happened to you?

WD. do you ever think about me?

A2 enters.

WD. where were you? we brought the coffee ten minutes ago?

A2. where's the other actor?

WD. out front. having coffee.

A2 exits.

WD. how's your mother?

A4. she died three years ago.

WD. what? why didn't you tell me?

A4. i didn't think you cared.

WD. i loved your mother. she was always nice to me.

A1 and A3 enter.

A1. my husband made a career out of the air force. he's overseas, and my daughter is away studying at tennessee state university.

A3. so you're all alone? aren't you scared living alone in this city?

A1. yeah, but my husband likes it here. he retires next year. he was stationed here as an air force recruiter after we left japan. he bought the house, and then they sent him back overseas. it's a nice house but too big for just me. i rattle around in it like a marble in a shoebox.
WD. coffee's out there, and hurry it up so we can get this thing going. A1. let's get some coffee. so where do you live?
A3. in a teeny studio apartment near downtown.
A1. that's a rough area.
A3. i know.
WD. and tell those guys to come on too!

A1 and A3 exit.

A4. is this play your tribute to her memory? she didn't use profanity and never said the word "nigger." you know that.
WD. your brother did. all he ever talked about was niggers, honkies, and other non sequiturs. he hated everybody.
A4. he liked you. you never gave him a chance.
WD. what chance did he give us?
A4. why blame our failure on him?
WD. why not?
A4. we didn't succeed because you were so damned paranoid.
WD. that's not true. we didn't succeed because you doubted my love. i love you.
A4. i never doubted your love.
WD. then you fell out of love with me.
A4. i did not.
WD. well, what happened?

a few moments of silence.

A4. you deceived me.
WD. how?
A4. you weren't there for me.
WD. when?
A4. the other day when you called me to come read your play.
WD. what's deceitful? you are reading my play.
A4. this is no play.
WD. what is it?
A4. it's a slap in my face. in my family's face.
WD. wrong.
A4. don't think i don't know what you're doing.
WD. what am i doing?
A4. you're mocking my family.
WD. wrong. do you want me to tell you?
A4. you don't have to tell me. i already know.

> *she throws the script down and exits. WD goes after her. A2 and A5 enter.*

A2. so you didn't say nothin' to him about us wanting to rap?
A5. no.
A2. why didn't you?
A5. i don't have a beef with him.

> *A1 and A3 enter.*

A2. we all got a beef with them. don't you understand, nigger?
A5. speak for yourself.
A3. are they acting or what?
A1. i don't think so.

WD enters.

WD. let's start act two. listen everybody, cut nigger.

A5. what nigger?

A1. which nigger?

WD. delete the word "nigger" and if your character uses profanity, just say the initials or expletive. everybody got that?

he reads from his script.

WD. ACT TWO, SCENE ONE. LIGHTS UP. IT IS THREE WEEKS SINCE THE PREVIOUS SCENE. CHASTITY BLANCHE IS STARING OUT OF THE WINDOW. BEAUREGARD COMES OUT OF THE BEDROOM. IT IS MIDAFTERNOON.

A5. WHERE'S MAMA?

A3. SHE WENT TO THE STORE.

A5. THEN LET'S DO IT! ROAR! I'M GONNA RAPE YOU!

A3. EEK! EEK! HELP! HELP!

WD. BEAUREGARD AND CHASTITY BLANCHE RUN AROUND THE APARTMENT, PLAYING.

A5. COME HERE, WOMAN!

WD. HE CATCHES HER.

A5. AH. GOTCHA! KISS ME! WD. THEY KISS.

A5. AGAIN!

WD. THEY KISS AGAIN.

A5. NOW DROP YOUR—

A3. NOT UNTIL NEXT MONDAY! DOCTOR'S ORDERS. WD. THE FUN STOPS.

A5. IT AIN'T BEEN SIX WEEKS YET?

A3. NOPE.

A5. EXPLETIVE . . . CAN I TOUCH IT?

A3. NO.

A5. JUST LEMME LOOK AT IT THEN.

A3. YOU'LL GET ALL HOT AND BOTHERED.

A5. YOU'RE MY WIFE! AIN'T I ENTITLED TO KNOW THAT MY WIFE IS STILL ALL THERE? IT'S BEEN EXPLETIVE NEAR THREE MONTHS.

A3. DO YOU THINK I MIGHT HAVE GROWN SOMETHING? YOU'RE RIGHT! YOU'RE OBSOLETE. I DON'T NEED YOU ANYMORE. I GREW WHAT I NEED.

A5. THAT AIN'T FUNNY WORTH A GOOD EXPLETIVE. I NEED YOU, BABY.

A3. WHAT DO YOU WANT ME TO DO?

A5. NOTHING.

WD. BEAUREGARD WALKS TO THE DOOR.

A3. WHERE ARE YOU GOING.

A5. UP ON THE ROOF.

WD. BEAUREGARD OPENS THE DOOR. A MIDDLE-AGED BLACK MAN WHOSE FACE HAS SEEN CENTURIES OF HORROR IS STANDING THERE. THIS IS CLEOPHUS LEE VESTER JACKSON, HIS FATHER, BUT HE DOESN'T KNOW HIM.

A2. IS THIS WHERE CLOREATHA LEE JACKSON STAYS?

A5. WHAT DO YOU WANT TO KNOW FOR?

A2. I'M A FRIEND OF HERS, YOUNG FELLA.

A5. WELL, SHE AIN'T HERE, OLD MAN.

WD. CLEOPHUS LEE SEES CHASTITY IN THE BACKGROUND.

A2. WHO'S THAT?

A5. NONE OF YOUR EXPLETIVE BUSINESS!

A2. LOOKS LIKE SHE'S BEEN CRYING.

A5. WHAT DO YOU WANT, OLD DUDE?

A2. YOU MUST BE BOYREGARD. CLOREATHA TALKS A LOT ABOUT YOU.

A5. HEY, OLD MAN. HAT UP.

WD. MOTHER JACKSON CALLS FROM OFFSTAGE.

A1. BO VESTER! BO VESTER!

A1. COME GIT ONE OF THESE BAGS!

A5. HERE I COME. DON'T BE HERE WHEN I GET BACK, OLD FELLA.

WD. BEAUREGARD EXITS. CHASTITY BLANCHE SPEAKS TO CLEOPHUS.

A3. WON'T YOU COME IN?

A2. IT IS UNWISE BEHAVIOR TO INVITE A STRANGER INTO YOUR HOUSE.

A3. YOU DON'T LOOK LIKE YOU WOULD HURT ANYBODY. COME IN.

WD. THE BABY CRIES OFFSTAGE.

A2. IS THAT A BABY I HEAR CRYING?

A3. YEAH, THAT'S OUR BABY. HE PROBABLY NEEDS CHANGING. EXCUSE ME.

A2. WHAT'S THE BABY'S NAME?

A3. JOSOYAM NAMGWEELE JACKSON. IT MEANS I AM THE MIXED FRUIT OF PURE TREES—THE COMBINATION OF SWEET TASTES. THE INCREDIBLE SAUCE. NEVER TOO HEAVY, NEVER TOO LIGHT BUT JUST RIGHT JACKSON. EXCUSE ME.

WD. HE EXITS TO THE BABY. MOTHER JACKSON ENTERS.

A1. YES?

A2. HELLO, MAY-MAY.

A1. LEE VESTER?

A2. YEAH. IT'S ME.

WD. BEAUREGARD APPEARS, CARRYING A BIG BAG OF GROCERIES.

A1. BO VESTER, CLOSE THE DOOR BEHIND YOU.

WD. BEAUREGARD ENTERS AND CLOSES THE DOOR. HE STANDS BY IT, HOLDING THE BAG, AND HEARS THE FOLLOWING SCENE.

A1. WHAT DO YOU WANT, LEE VESTER?

A2. CLO-CLO ASKED ME TO COME TALK TO HER BROTHER.

A1. YOU AIN'T NEVER CARED NOTHIN' ABOUT HIM BEFORE. WHY ALL OF A SUDDEN YOU'RE TAKING SUCH A GREAT INTEREST IN HIM?

A2. AIN'T YOU GONNA INVITE ME IN?

A1. NOPE. WHAT YOU GOT TO SAY, YOU CAN SAY IT RIGHT HERE.

A2. CLO-CLO CAME OVER TO MY PLACE YESTERDAY.

A1. HOW DID SHE KNOW WHERE YOU LIVE?

A2. MY MAMA GAVE HER THE ADDRESS A LONG TIME AGO BEFORE SHE DIED. SHE LOOKS JUST LIKE MAMA, BEAUTIFUL GIRL. YOU COULDN'T KEEP HER AWAY FROM ME, MAY-MAY.

A1. YOU AIN'T NEVER DONE NOTHIN' FOR HER.

A2. I INTRODUCED HER TO BOOKS AND OPENED HER MIND TO SOME OF THE GREATEST THOUGHTS IN THE WORLD. THE BEST THING YOU COULD'VE DONE FOR ME WAS TURN ME IN, MAY-MAY. I CLEANED UP AND READ EVERYTHING I CAN GET MY HANDS ON. AND I FOUND OUT WHY I WAS THE WAY I WAS. I HAD BEEN ALIENATED FROM MYSELF, LIVING AMONG ALIENS, WORSHIPPING ALIEN GODS.

A1. HUSH THAT BLASPHEMOUS TALK, LEE VESTER. NOW I KNOW WHERE CLO-LEE GOT ALL THEM DEVILISH IDEAS.

A2. DON'T PULL THAT MAMA SHIT—ER, POOPOO—ON ME, MAY-MAY. YOU SAVE THAT STUFF FOR YOUR CHILDREN. ME AND YOU LAID UP AND MADE THEM. I AIN'T YOUR CHILD. I AM YOUR MAN. I KNEW YOU BEFORE YOU WERE MAMA.

A1. I DON'T WANT TO HEAR IT!

A2. YOU'RE GONNA HEAR IT ANYWAY, WOMAN.

A1. LET GO OF ME!

A2. I'LL BREAK YOUR NECK!

A1. LET ME GO!

A2. SHUT UP!

WD. BEAUREGARD ENTERS AND CLOSES THE DOOR.

A5. we just did that.

WD. well, i want to hear it again. keep going.

A1. why?

A2. yeah, why do we have to read something we already read?

WD. okay, i'll fix it in the rewrite.

A4. you're going to be doing a lot of rewriting.

WD. there's a lot of things that have to be fixed, but let's not stop the reading to do it now. okay?

 silence

WD. okay. read the script as is…

 he reads

(back to the script)

WD. BEAUREGARD ENTERS AND CLOSES THE DOOR. HE STANDS BY IT HOLDING THE BAG AND HEARS THE FOLLOWING SCENE.

A1. WHAT DO YOU WANT, LEE VESTER?

A2. CLO-CLO ASKED ME TO COME TALK TO HER BROTHER. A1. YOU AIN'T NEVER CARED NOTHIN' ABOUT HIM BEFORE. WHY ALL OF A SUDDEN YOU'RE TAKING SUCH A GREAT INTEREST IN HIM?

A2. AIN'T YOU GONNA INVITE ME IN?

A1. NOPE. WHAT YOU GOT TO SAY, YOU CAN SAY IT RIGHT HERE.

A2. CLO-CLO CAME OVER TO MY PLACE YESTERDAY.

A1. HOW DID SHE KNOW WHERE YOU LIVE?

A2. MY MAMA GAVE HER THE ADDRESS A LONG TIME AGO. BEFORE SHE DIED. SHE LOOKS JUST LIKE MAMA. BEAUTIFUL GIRL. YOU COULDN'T KEEP HER AWAY FROM ME, MAY-MAY.

A1. YOU AIN'T NEVER DONE NOTHIN' FOR HER.

A2. I INTRODUCED HER TO BOOKS. OPENED HER MIND TO SOME OF THE GREATEST THOUGHTS IN THE WORLD. THE BEST THING YOU COULD'VE DONE FOR ME WAS TURN ME IN, MAY-MAY. I CLEANED UP, AND READ EVERYTHING I CAN GET MY HANDS ON. AND I FOUND OUT WHY I WAS THE WAY I WAS. I HAD BEEN ALIENATED FROM MYSELF. LIVING AMONG ALIENS. WORSHIPPING ALIEN GODS.

A1. HUSH THAT BLASPHEMOUS TALK, LEE VESTER. NOW I KNOW WHERE CLO-LEE GOT ALL THEM DEVILISH IDEAS.

A2. DON'T PULL THAT MAMA SHIT . . . ER POOPOO ON ME, MAY-MAY. YOU SAVE THAT STUFF FOR YOUR CHILDREN. ME AND YOU LAID UP AND MADE THEM. I AIN'T YOUR CHILD. I AM YOUR MAN. I KNEW YOU BEFORE YOU WERE MAMA.

A1. I DON'T WANT TO HEAR IT!

A2. YOU'RE GONNA HEAR IT ANYWAY, WOMAN.

A1. LET GO OF ME!

A2. I'LL BREAK YOUR NECK!

A1. LET ME GO!

A2. SHUT UP!

A1. OUCH!

WD. BEAUREGARD SETS THE BAG DOWN AND OPENS THE DOOR.

A5. ARE YOU ALL RIGHT, MAMA?

WD. MAMA BACKS IN THE DOOR.

A1. YEAH, EVERYTHING IS OKAY, BO VESTER. HERE TAKE THIS OTHER BAG AND PUT IT IN THE KITCHEN.

A2. HOW ARE YOU, BOY?

A5. MAN. OLD DUDE. MAN.

A2. I GOT SOMETHING I WANT TO SAY TO YOU AND YOUR WIFE.

A5. WE DON'T WANT TO HEAR IT.

A2. MAY-MAY, TELL YOUR SON TO LISTEN TO HIS FATHER.

A1. BO VESTER, LISTEN TO YOUR DADDY.

A5. YOU'RE MY DADDY, HUH?

A2. CALL YOUR WIFE.

A5. SHE AIN'T BRINGING THE BABY OUT IN THIS DRAFT.

A2. CAN I COME INSIDE, MAY-MAY?

A1. YEAH. GO ON. BUT DON'T MAKE YOURSELF AT HOME.

WD. CLEOPHUS LEE COMES INSIDE AND CLOSES THE DOOR BEHIND HIM. HE DOESN'T MOVE INTO THE APARTMENT. BEAUREGARD CALLS TO HIS WIFE.

A5. CHASTITY BLANCHE! COME OUT HERE FOR A MINUTE! WD. SHE ANSWERS FROM OFFSTAGE.

A3. I'M NURSING THE BABY.

A5. THERE'S SOMETHING SOMEBODY WANTS YOU TO HEAR.

A3. OPEN THE DOOR. I CAN HEAR FROM HERE.

WD. BEAUREGARD OPENS THE DOOR TO THE BEDROOM. A5. SPEAK YOUR PIECE, MR. JACKSON.

A2. I CAME BY BECAUSE CLO-CLO BEGGED ME TO. SHE LOVES YOU BOYREGARD. SHE'S UPSET BECAUSE YOU HAVE MARRIED THAT GIRL IN THERE. ARE YOU SURE THAT YOU ARE WITH THAT GIRL BECAUSE YOU LOVE HER? OR ARE YOU WITH HER BECAUSE OF WHAT SHE REPRESENTS?

WD. CHASTITY SPEAKS FROM OFFSTAGE.

A3. WHAT DO I REPRESENT?

A2. A STANDARD OF BEAUTY WHICH IN NO WAY REFLECTS HIS MAMA.

WD. CHASTITY SCREAMS.

A3. I WANT TO GET OT OT THIS HELL—er, H!

A5. MISTER JACKSON, YOU BETTER SPLIT! YOU JUST UPSET MY WIFE. MAKE IT!

WD. BEAUREGARD MOVES TOWARD HIS FATHER.

A1. BO VESTER, DON'T HIT HIM.

WD. BEAUREGARD RESTRAINS HIMSELF.

A1. LEE VESTER, GO HOME!

WD. CLEOPHUS LEE OPENS THE DOOR BEHIND HIM.

A2. DON'T MAKE THE SAME MISTAKE I MADE, SON. DON'T TIE YOURSELF DOWN TO A WOMAN JUST SO YOU HAVE SOMEBODY TO LAY UP IN BED WITH. THAT'S THE MISTAKE I MADE. THERE'S MORE TO LOVE THAN THAT.

A5. YOU OLD MOTHER EXPLETIVE! GIT OUT!

A1. BO VESTER! STOP THAT CUSSIN'.

A2. YOU'RE GONNA IGNORE ME AND MAKE THE SAME MISTAKE I DID.

A5. YOU SET THE EXAMPLE.

A2. DON'T DO LIKE I DO. DO LIKE I SAY DO.

A5. HOW CAN YOU TEACH ME ANYTHING?

A2. I AM YOUR FATHER.

A5. I AIN'T GOT NO FATHER. YOU NEVER DID AN EXPLETIVE THING FOR ME.

A2. SO WHAT? YOU SURVIVED, DIDN'T YOU?

A5. NO THANKS TO YOU!

WD. MAMA INTERVENES.

A1. BO VESTER, BE QUIET! THIS IS YOUR DADDY. IF IT WASN'T FOR HIM, YOU WOULDN'T BE HERE.

WD. SHE SPEAKS TO CLEOPHUS.

A1. LEE VESTER! CARRY YOUR SHRIVELED BEHIND BACK WHERE IT CAME FROM . . . COUGHIN' AND CARRYIN' ON. YOU AIN'T COMIN' HERE TO DIE!

A2. THAT SURE IS COLD, MAY-MAY.

A1. COLD IS COLD, AND BOLD IS BOLD. NOW GIT, GIT!

WD. LEE VESTER LEAVES. CHASTITY BLANCHE ENTERS.

chastity, where are you?

A3 calls from offstage.

A3. i didn't hear nigger.

WD. it's been deleted.

A3 enters.

A3. sorry.

WD. yeah! CHASTITY BLANCHE ENTERS.

A3. BO, WHO WAS THAT UGLY MAN?

A1. YOUR HUSBAND IN ABOUT THIRTY YEARS IF HE DON'T MAKE SOMETHING OUT OF HIMSELF.

WD. MAMA CLOSES THE DOOR AND GOES INTO THE KITCHEN AREA.

A5. I DON'T LOOK LIKE HIM. WD. THE BABY CRIES OFFSTAGE.

A1. THE BABY IS CRYING.

A3. HE'LL BE ALL RIGHT, MOTHER JACKSON.

A1. I WANT TO LOOK AT HIM. I AIN'T SEEN HIM ALL DAY, AND GRANDMA LOVES HER LITTLE BOOGER. CAN I HOLD HIM FOR A WHILE?

A3. OKAY, MOTHER JACKSON.

WD. MAMA EXITS INTO THE BEDROOM. SOON THE BABY STOPS CRYING.

A3. BO?

A5. WHAT'S HAPPENING, BABY?

A3. WHEN ARE WE GONNA MOVE FROM HERE?

A5. AS SOON AS I GET A JOB.

A3. HAVE YOU BEEN LOOKING?

A5. SURE I HAVE, C. C.

A3. WHERE HAVE YOU BEEN LOOKING, BO?

A5. AW, COME ON, CHASTITY MAMA. DON'T START THAT.

A3. BO, WE HAVE BEEN LIVING HERE OFF OF YOUR MOTHER AND HER MEASLY WELFARE CHECK FOR ALMOST SIX WEEKS NOW.

A5. I KNOW. I KNOW. THERE JUST AIN'T NO JOBS. THERE'S A RECESSION GOING ON.

A3. BO, WHAT IS WRONG?

A5. I WANT SOME RESPECT.

A3. ONLY UNTIL NEXT MONDAY.

A5. GIMME SOME MONEY. I'M GOIN' TO GET A BOTTLE.

A3. WE DON'T HAVE ANY MONEY LEFT.

WD. BEAUREGARD CALLS TO HIS MAMA.

A5. MAMA!

A3. WHAT ARE YOU CALLING YOUR MOTHER FOR?

A5. SHE GOT MONEY. HER WELFARE CHECK CAME YESTERDAY.

WD. MAMA ANSWERS FROM OFFSTAGE.

A1. YES, SON?

A3. BO, DON'T BOTHER YOUR MOTHER FOR HER MONEY.

A5. YOU MAY HAVE TO GO ON WELFARE SOON. I'LL HAVE TO LEAVE THE HOUSE. YOU CAN'T GET IT IF I LIVE WITH YOU.

WD. MAMA ENTERS, HOLDING THE BABY.

A1. WHAT IS IT, BO VESTER?

A3. NOTHING, MOTHER JACKSON.

A1. THE BABY IS ALMOST ASLEEP. YES, HIM IS. PRETTY LITTLE THING.

A3. MOTHER JACKSON, WHY IS BO ACTING SO STRANGE?

A5. WHY ASK HER? ASK ME! I'M RIGHT HERE! WHY DO YOU BRING MY MOTHER INTO OUR BUSINESS?

A3. BO, I JUST WANT TO UNDERSTAND YOU.

A5. YOU DON'T UNDERSTAND ME?

A3. NO, SOMETIMES I DON'T!

A5. THEN WHY DID YOU MARRY ME?

A3. I LOVE YOU.

A5. MAYBE I AM JUST A DUMB DARKY WITH A DONKEY EXPLETIVE.

WD. HE WALKS TOWARD THE DOOR.

A5. I'M GOING OUT.

A3. WHERE ARE YOU GOING, BO?

A5. TO GIT RID OF A THREE-MONTH LOAD. WD. HE EXITS. CHASTITY SCREAMS.

A3. YOU S.O.B., A.H., M.F.'er. I HATE YOU!

WD. MAMA MOVES TO CONSOLE HER.

A3. I WANT TO GO HOME.

A1. THERE, THERE, NOW, DARLING, GO ON AND CRY. I CRIED ONCE. ABOUT HIS DADDY. SWORE I WOULDN'T CRY NO MORE. I SAW A STRONG FINE-LOOKING YOUNG MAN TURN INTO A SMELLY, SNEAKY ROGUE. I CRIED, HONEY. I CRIED.

A3. I WISH I NEVER HAD HAD HIS BABY.

A1. I KNOW HOW YOU FEEL, DARLIN'. BUT DON'T HOLD IT AGAINST THE BABY. IT'S AN INNOCENT LITTLE THING. DON'T KNOW NOTHIN' ABOUT NOTHIN'.

A3. HE USED TO BE SO KIND AND THOUGHTFUL.

A1. SWEET WORDS DON'T BUY NO GROCERIES AND DON'T PAY NO RENT.

WD. MOTHER JACKSON CRADLES CHASTITY IN ONE ARM AND THE BABY IN THE OTHER. SHE SINGS HER SONG SOFTLY AS THE LIGHTS FADE TO BLACK.

A2 joins A1. they laugh.

WD. what's so funny?
A1. nothing.
WD. what are you laughing about?
A2. nobody.
WD. we know better than that.
A2. okay, you got enough time. we'll tell you.
WD. you're laughing at us.
A2. we are?
WD. yes, you are.
A2. we don't know that.
WD. we do, you're laughing at us. come on, what is it?
A2. you tell us, and we'll all know.
WD. you're a dumb ass.
A2. say, what?
WD. i'm talking to the director. i want to talk to you. not here in front of the actors. then let's step outside. just a second. okay, everybody, take a break . . . gotta have a quick conference with the writer.
A3. hey, i gotta go to work pretty soon.
WD. it'll be a short powwow.

WD exits. A2 approaches A5.

A2. roll call. If you ain't with us, you're against us.

A1 speaks to A3.

A1. i'm thinking about having a barbecue in my backyard on the fourth of july. would you like to come? my daughter will be home from school, and i'm sure she would like to meet you.

A5. so if i don't subordinate myself to your will, then i'm your enemy?

A3. i'll probably have to work that day.

A2. he's an outsider. he doesn't understand us.

A1. well, come when you get off.

A2. i'm tired of being stereotyped.

A5. stop acting.

A3. okay. thanks.

A1. good. i'll give you my address and telephone number before you leave.

A2. we must never let ourselves be defined by anyone other than ourselves.

enter WD.

WD. we're back.

A5. i'm not in it.

A2. our children are gonna want to know what we did. what shall we tell them?

A5. if you ain't got something good to say about somebody, say nothing.

WD. what is it this time, fellas?

no answer.

WD. nothing, huh? okay. ACT TWO, SCENE THREE. A FEW HOURS LATER, CLOREATHA ENTERS WITH LEE VESTER.

A4. COME ON IN, DADDY.

A2. I'LL JUST WAIT HERE BY THE DOOR. GIT YOUR THINGS, AND LET'S GO.

WD. MAMA'S VOICE IS HEARD FROM THE BEDROOM.

A1. WHO'S THERE? IS THAT YOU, HONEY DOLL?

WD. LEE VESTER DUCKS OUT OF SIGHT. MAMA ENTERS. SEES CLOREATHA.

A1. YOU DONE COME BACK, HUH? WELL, YOU'RE GONNA HAVE TO STRAIGHTEN UP IF YOU WANT TO LIVE IN THIS HOUSE. YOUR DEVILMENT AND RADICAL IDEAS DONE CAUSED ENOUGH TROUBLE IN THIS PLACE. BO VESTER'S OUT IN THE STREETS DOIN' GOD KNOWS WHAT, AND HIS WIFE TOOK THE BABY AND LEFT.

A4. GOOD.

A1. CLOREATHA, HOW CAN YOU BE SO SPITEFUL? YO' DADDY PUT THAT FOOLISHNESS IN YO' HEAD, DIDN'T HE? NO GOOD DEVIL.

WD. LEE VESTER SHOWS HIMSELF. CLOREATHA EXITS TO HER BEDROOM.

A2. YOU'RE THE ONE NO GOOD, MAY-MAY.

A1. WHAT ARE YOU DOING HERE?

A2. BEING A NIG—er, DELETED.

WD. CLOREATHA ENTERS CARRYING A SUITCASE AND A CLOTHING BAG. SHE GIVES THE SUITCASE TO LEE VESTER.

A4. HERE, DADDY. THERE'S ONE MORE SUITCASE.

A2. I'LL COME BACK AND GET IT.

A4. I WON'T BE BACK NO MORE, MAMA.

WD. THEY EXIT. MAMA GOES TO THE KITCHEN. GETS A BUTCHER KNIFE.

A1. LORD, I HOPE YOU WILL FORGIVE ME FOR WHAT I'M GONNA DO, BUT I CAN'T LET THIS MAN DESTROY MY LIFE.

WD. MAMA HIDES BEHIND THE DOOR. BEAUREGARD ENTERS. WITHOUT LOOKING, MAMA PLUNGES THE KNIFE IN HIS BACK. BEAUREGARD LOOKS AT HER.

A5. MAMA?

A1. OH, LORD JESUS! I THOUGHT YOU WERE YOUR DADDY.

WD. BEAUREGARD DIES.

A1. I DONE KILLED MY BABY.

WD. LEE VESTER ENTERS. SEES MAMA SITTING BEAUREGARD ON THE SOFA.

A2. WHAT'S WRONG WITH THAT BOY?

A1. YOU KILLED HIM, CLEOPHUS LEE VESTER! YOU KILLED HIM!

WD. SHE LUNGES AT HIM. HE DUCKS AND DODGES.

A1. I'M GONNA KILL YOU!

A2. WOMAN, PUT THAT KNIFE DOWN!

A1. YOU ARE NOT GOING TO DESTROY ALL I HAVE WORKED FOR.

WD. HE HOLLERS OUT OF THE WINDOW.

A2. CLO-CLO! CLO-CLO! YOUR MAMA DONE GONE CRAZY!

A1. I SHOULD'VE KILLED YOU A LONG TIME AGO.

WD. CLOREATHA ENTERS.

A4. WHAT IS ALL THE YELLING ABOUT?

A2. SHE DONE KILLED BEAUREGARD.

WD. CLOREATHA RUSHES TO BEAUREGARD'S BODY.

A4. BO BO!

A1. I'M GONNA KILL ALL OF Y'ALL DEVILS.

WD. SHE STABS CLOREATHA.

A4. DADDY! BO BO! DADDY!

A2. CLO-CLO!

WD. LEE VESTER ATTACKS MAMA WITH HIS BARE HANDS. THEY WRESTLE AROUND THE ROOM. MAMA CUTS HIM SEVERAL TIMES. HE IS DYING. WITH HIS LAST BIT OF STRENGTH, HE GRABS MAMA'S KNIFE HAND AND TURNS THE KNIFE BACK ON HER, CAUSING HER TO STAB HERSELF WHILE HE EMBRACES HER IN A DEATH HUG.

A2. YOU'RE THAT FINE YOUNG THANG, MAKE MY JOHNSON HARDER THAN COMPUTER MATHEMATICS. OOH, BABY, MY LOVE IS COMING DOWN.

A1. I DON'T NEED THAT NO MORE, LEE VESTER. I GOT ME A LOVE GREATER THAN ANY YOU COULD EVER FEEL FOR ME.

A3. BO? MOTHER JACKSON?

A1. WHO'S THAT?

A4. THE SPIRIT WHO PLAYED HIS WIFE IN LIFE.

A3. BO? BO? MOTHER JACKSON! WHERE ARE YOU?

A4. THAT SPIRIT ISN'T FREE YET. IF IT WERE, IT WOULD KNOW WHERE WE ARE. IT IS STILL ATTACHED TO LIFE.

A3. BEAUREGARD? MOTHER JACKSON?

A2. IT'S GETTING CLOSER. I DON'T WANT NOTHING TO DO WITH IT. I'VE BEEN THROUGH LIFE TOO MANY TIMES ALREADY.

WD. THEY HAVE MELTED INTO THE SHADOWS. CHASTITY CALLS.

A3. BEAUREGARD! BEAUREGARD!

A5. OVER HERE, CHASTITY BLANCHE.

WD. CHASTITY BLANCHE APPEARS. BEAUREGARD AND CLOREATHA FADE INTO THE SHADOWS.

A3. BO? WHERE ARE YOU?

A4. HOW DID YOU GET HERE?

A3. CLOREATHA? DO YOU STILL HATE ME?

A4. NO.

WD. more feeling, chastity. mean it. like this. do you still hate me?

A4. NO.

A5. WHERE IS THE BABY?

A3. BO? DO YOU LOVE ME?

WD. don't you understand the meaning of the question? do you love me?

A3. yeah. she wants to know if he loves her.

WD. no. she is really telling him that she loves him. she is saying, i love you. i love you with all my heart. try it again with the feeling of "i love you" unspoken.

A5. WHERE IS THE BABY?

A3. BO? DO YOU LOVE ME?

A5. I DON'T LOVE OR HATE. MY SPIRIT IS FREE OF THOSE ENTANGLEMENTS. FOR A WHILE ANYWAY.

A3. YOU SOUND STRANGE, BO. ALMOST AS IF YOU WEREN'T WHO YOU ARE.

A5. I'M NOT.

A3. I PUT THE BABY ON THE BED WITH A FULL BOTTLE AND A NOTE EXPLAINING TO WHOEVER FINDS OUR BODIES THAT I FOUND ALL OF YOU DEAD AND DECIDED TO KILL MYSELF. I FOUND THE BUTCHER KNIFE AND COMMITTED SUICIDE. BO, I LOVE YOU. I WANTED TO FIND OUT WHY. WHY YOU ALL KILLED YOURSELVES. I THOUGHT MAYBE THAT IF I KILLED MYSELF, I MIGHT FIND YOU AND GET SOME ANSWERS.

WD. A VOICE IS HEARD OFF LIMBO. IT IS THE TRANSPORTER'S SPIRIT. i'll read the voice of the transporter spirit. NIFFLE NEE APEPLE.

A4. NOAN WIGGIE YUSHVEEBOW!

A5. WE HAVE TO GO.

WD. BREE NONGOO, CLEOPHUS LEE VESTER JACKSON.

A2. ZAH BAH KEE!

A3. THERE'S YOUR FATHER, BO.

A5. IT IS NO LONGER MY FATHER. IT IS JUST ANOTHER SPIRIT.

WD. BREE NONGOO, MARY RUTH JACKSON.

A1. ZAH BAH KEE.

A3. HI, MOTHER JACKSON.

A5. THAT SPIRIT NO LONGER RECOGNIZES YOU.

WD. BREE NONGOO, BEAUREGARD SYLVESTER JACKSON.

A5. ZAH BAH KEE.

A3. BO? DON'T GO!

WD. no. no. the one you love is going. leaving you all alone. feel the coldness of abandonment. you're being deserted. just because you're human. you're not perfect. but you love with all your heart and soul.

A4. TOO LATE. HE'S PASSED OVER.

A3. CLOREATHA, I WANT TO FIND OUT WHY.

WD. BREE NONGOO, CLOREATHA LEE VESTER JACKSON.

A4. ZAH BAH KEE.

A3. I WANT TO GO TOO!

WD. THE SPIRITS DISAPPEAR. CHASTITY BLANCHE IS LEFT BY HERSELF.

A3. WHY? WHY?

WD. AN AMPLIFIED VOICE IS HEARD. you four actors read this voice in unison and circle around chastity real spooky-like.

VOICE. BRRRRRRRRRRRRTHWEEEEEPEEEEEEEEZIT. CHASTITY BLANCHE JACKSON, YOU ARE NOT YET A FREE SPIRIT. YOU MUST KEEP ON LIVING.

A3. WHY?

WD begins to direct A3 and say her lines.

VOICE. YOUR TIME IS NOT UP YET.

WD/A3. I KILLED MYSELF.

VOICE. YOU CANNOT KILL YOURSELF NOR CAN YOU BE KILLED UNLESS IT IS WRITTEN. YOU CANNOT CHANGE WHAT IS. YOU WILL DIE WHEN YOUR TIME COMES.

WD/A3. IF I CANNOT CHANGE THE TIME OF MY DEATH, IS THERE ANYTHING I CAN DO TO CHANGE MY LIFE?

VOICE. ONLY IF IT IS WRITTEN.

WD/A3. HOW DO I KNOW IF IT IS WRITTEN OR NOT?

VOICE. YOU DON'T. LIVE AND YOU WILL DISCOVER YOUR LIFE.

WD takes over A3's role. the actors circle him at a frenetic pace. A3 joins them.

WD/A3. WHEN?

VOICE. WHEN YOU ARE FREE. NERREEEEEEEEEEEE FIN.

WD/A3. I WANT SOME ANSWERS. WHO ARE YOU? WHERE ARE YOU? WHO AM I? WHERE AM I? I WANT SOME ANSWERS. WHY? WHY?

WD rants and raves as the actors encircle him and chant, "WHEN YOU ARE FREE."

ACTORS. when you are free, when you are free.

> *A4 extricates herself from the circle and goes to WD. she embraces him and succeeds in calming him down. slowly everything becomes quiet and still. WD regains his composure and reads from his script.*

WD. THE LIGHTS GO DOWN AS CHASTITY BLANCHE CONTINUES TO SCREAM. LOUD KNOCKING IS HEARD. THE LIGHTS COME UP. THE PLACE IS THE JACKSON'S APARTMENT. THE BODIES OF MOTHER JACKSON, CLOREATHA, BEAUREGARD, AND CLEOPHUS ARE WHERE THEY WERE IN THE KILLING SCENE. CHASTITY BLANCHE LIES ON THE FLOOR NEXT TO BEAUREGARD'S BODY. THE BUTCHER KNIFE PROTRUDES FROM HER LOWER ABDOMEN. SHE STIRS SLIGHTLY. OFFSTAGE FROM THE BEDROOM, THE BABY CRIES. CHASTITY MUMBLES.

A3. WHO AM I? WHERE AM I? WHAT DO I HAVE TO LEARN?

WD. THE KNOCKING AT THE DOOR CONTINUES, AND THEN A VOICE IS HEARD, "OPEN UP! POLICE!" THE LIGHTS GO DOWN RAPIDLY, THE KNOCKING, CRYING, AND MUMBLING CONTINUE. THE END.

A3. i gotta go to work.

A2. hey, baby, let me get your address and telephone number. A3. buzz off.

> *she exits to bathroom.*

A4. (*to WD*) i see you're still hung up.

WD. it ain't no big thing.

he exits.
A1 approaches A2.

A1. are we going to say something to him about this play? A2. if we can get blippy to stand up with us.

A5 approaches A4.

A5. what's wrong, sister?
A4. nothing.
A5. but you seem upset. is there anything i can do?
A4. i'll be okay, thanks.

A1 and A2 approach A5.

A2. hey, brother man, we're going to say something to him about this play. where do you stand?
A5. as far away from the shit as i can.
A2. can't be no conscientious objectors.
A5. leave me alone.
A2. no! declare yourself!
A1. yeah! where are you?
A5. somewhere between tomorrow and yesterday.
A1. what?
A2. hey, baby, let me rap to this blue hippy. he'll trip out on you, but i can hang. i am a space traveler.
A5. brother, i have already told you. i have nothing against the man or his play, you do. i'm not in it.
A4. what about his play?
A2. you stay out of this, honkey lover! ain't nobody talkin' to you!

A5. hey, brother. why don't you lighten up? can't you see the sister doesn't feel well?
A1. what's wrong, girl?
A2. it is because of flippie-dippies like you . . .
A1(*interrupting*). take that noise somewhere else.
A2. okay. (*to A5*) come here, man. let me school you.

they move away from A1 and A4.

A2. you are more dangerous than ten of the enemy, zippin' around talking about you're an individual. you are nothing to them.
A2. we don't like it.
A5. what we, blood? you got a mouse in your back pocket?
A2. i don't like you, blippy. you jiveass. i hate you.

A4 screams.

A4. just who in the hell do you think you are? you don't like him. you don't like me. you don't like my ex-husband, and you don't like his play. what's really bothering you is you don't like yourself!
A2. don't be screaming at me.
A4. i'll scream all i want. what are you going to do? hit me?

WD moves to restrain her.

WD. calm down, sweetheart.
A4. don't tell me to calm down. i am calm, i'm just sick and tired of this loudmouth putting down everything. (*to A2*) you don't like this play? write one yourself. you don't like my ex? get out of his theater.

A2. i helped build this theater. you can't kick me out. you're way off base. i was here making this place happen. where were you?

A3. nice meeting you.

A1. i'll walk out with you so i can give you the information.

A3. (*to WD*) are you going to do the play?

WD. i don't know, please go. leave the scripts here.

A1(*to A2*). come on.

A2. no! i want to know where she was while i was down here sweating and building. probably sitting on her seditty behind somewhere acting like grand miss anne, wife of mister charlie, thinking she's too good to be around us. talking all that high and mighty jive, like just because she was whitey's wife, that gives her some kind of right to talk to me as if i were a dog. (*to A4*) you better git hip to what's really happening, miss thang. you ain't nothin' but another nigger to him.

WD. whoa! hold on, mister, you're barking up the wrong tree.

A2. am i?

WD. yes.

A2. well, why isn't she still your wife?

WD. that's personal.

A2. oh, yeah. hah! you just personally got tired of her black butt. i know you people are all the same—you, my wife, all of you. (*to A4*) we're the wrong color, sister. they use us, and when they're through with us, they throw us away like so much garbage.

A4. i left him . . .

WD. sweetheart, don't . . .

A4. no. let me finish. i left him because i wasn't strong enough . . .

A2. why do you women always hide behind being weak when things get rough?

WD. she's not hiding.

A4. i wasn't strong enough to take the hatred we experienced because of who we were and what we meant to each other. nobody wanted to see us together.
A1. (*to A2*) you ought to be able to identify with that.
A4. nobody. and when my pregnancy began to show, everybody—black, white, family, and others—made our living together unbearable.
WD. everybody except your dear, sweet mother. she was a saint.
A4. i tried to bear up, but it was too much for me. i lost our baby, our baby . . .

she chokes up. WD embraces her.

WD. i love you very much.
A2. hey, man. i'm sorry, but you never talked about . . .
WD. while we were here building this theater, she was in the hospital. i wasn't there for her.
A2. i didn't know.
WD. just go.
A2. god, what a fool i am. i want to apologize to everybody here. i don't want to be the way i am. please forgive me, everybody. i'm so tired of being used against myself. god, what a fool i am.
A5. come on, brother. don't make matters worse.
A2. i didn't know. he never talked about that. i didn't know.
A5. you shouldn't have been talking out of school.
A2. yeah. you're right.
A5. you're always puttin' your foot in your mouth.
A2. that's what i like about you, brother. you tell it like it is. you're all right with me.

A1 exits with A3 followed by A2 and A5.
lights go down slowly

THE END

www.ingramcontent.com/pod-product-compliance
Lightning Source LLC
Chambersburg PA
CBHW060047230426
43661CB00004B/684